Paint Happy!

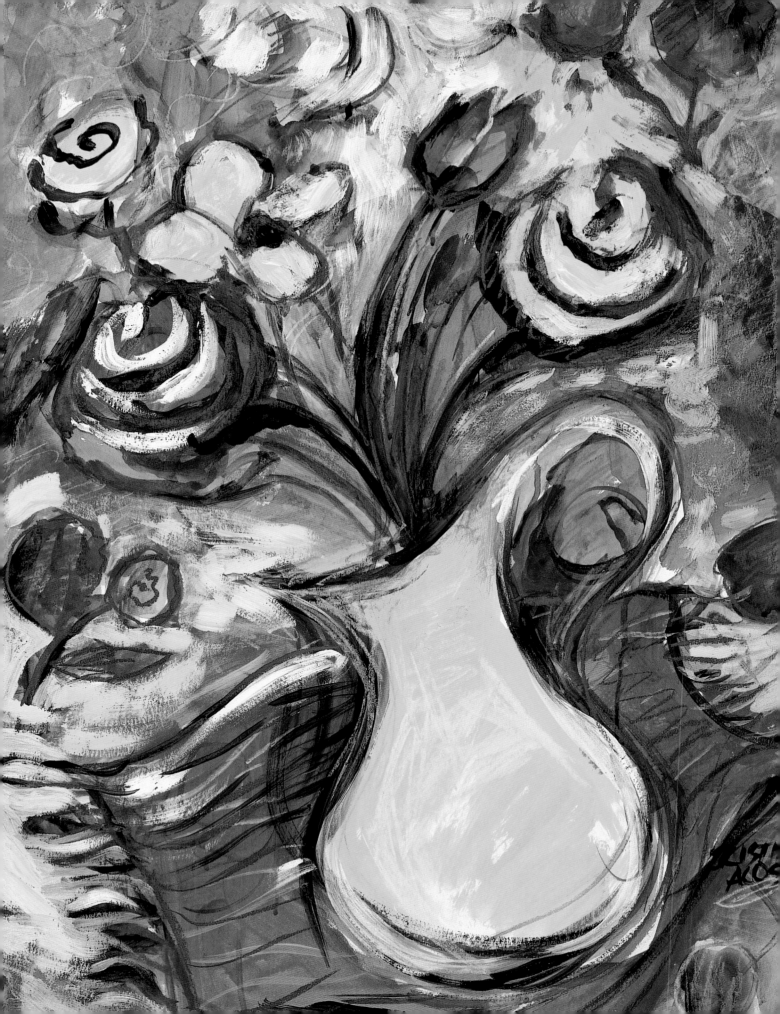

Paint Happy!

Cristina Acosta

NORTH LIGHT BOOKS
CINCINNATI, OHIO
www.artistsnetwork.com

About the Author

Cristina Acosta is a vibrant and prolific artist whose bright, magical style conveys a sense of joyous spirit. She applies her artistic vision to a variety of mediums, receiving national acclaim for her artwork. Her artistry has been featured in a variety of books and magazines, including *Better Homes and Gardens*, *House Beautiful*, *Latina* magazine, *Good Housekeeping* and *Woman's Day* home design publications. She continually paints for gallery shows and develops her signature line of licensed home and gift items that are distributed nationwide.

Cristina is a classically trained painter. Born in southern California and professionally mentored from the age of eleven, she earned her bachelor of fine arts in painting from the University of Oregon in Eugene. She was an artist for outdoor advertising billboard murals and lettering for two years before teaching art for five years at the college level. During that time she developed her personal style and began showing her artwork in a variety of venues nationwide.

Cristina is deeply influenced by her own multicultural heritage. The influences of her Latin-American and Polish-American grandmothers combined to create a tapestry of cultures rich in visual imagery. The artist lives in Bend, Oregon, with her husband, Randall Barna, and her daughter, Isabella. Additional information about Cristina can be found on her Web site at www.CristinaAcosta.com.

Artwork on page 2:

Yellow Vase · acrylic and pastel on paper · 30" x 22" (76cm x 56cm) · collection of Mark and Josie Belza

Photos on pages 13-17, 32 and 102-103 by Gary Alvis.

06 05 04 03 02 5 4 3 2 1

Library of Congress Cataloging-in-Publication Data
Acosta, Cristina.
 Paint happy! / Cristina Acosta.
 p. cm.
 Includes index.
 ISBN 1-58180-118-1 (pbk. : alk. paper)
 1. Painting—Technique. I. Title.

ND1473 .A27 2002
751.4—dc21 2002020189
 CIP

Editor: Stefanie Laufersweiler
Designer: Wendy Dunning
Layout artist: Kathy Bergstrom
Production coordinator: John Peavler

Metric Conversion Chart

To convert	to	multiply by
Inches	Centimeters	2.54
Centimeters	Inches	0.4
Feet	Centimeters	30.5
Centimeters	Feet	0.03
Yards	Meters	0.9
Meters	Yards	1.1
Sq. Inches	Sq. Centimeters	6.45
Sq. Centimeters	Sq. Inches	0.16
Sq. Feet	Sq. Meters	0.09
Sq. Meters	Sq. Feet	10.8
Sq. Yards	Sq. Meters	0.8
Sq. Meters	Sq. Yards	1.2
Pounds	Kilograms	0.45
Kilograms	Pounds	2.2
Ounces	Grams	28.4
Grams	Ounces	0.04

Acknowledgments

The life of an artist is rich and rewarding. A moment that may seem insignificant to most people stays with me for a lifetime. A casual acquaintance long ago mentioned that he bought a yellow car because the color seemed "so happy"; at that moment, I understood that every color has a particular energy, and I began looking at color much more carefully. In that sense, many people, known or unknown to me, have contributed to my artistry. I am thankful to have been born in a country that attracts citizens from all of the world's cultures. The resulting tapestry of people has created a variety of rich visual imagery. I live in a country that believes in public education, museums and libraries for everyone, and I am a grateful recipient.

I am thankful to my grandparents for their gifts, especially to my grandmothers, Catalina Maria Ortiz Acosta and Alice Anne Slupska Wisner. When I think of either of you, I think of the beauty of life—the taste of a fruit or the scent of a flower fresh from the garden, the sound of classical music on the sea air, and the love of needlework and painting.

I am grateful that my parents, Sandra Diane Wisner Acosta and Joaquin Enrique Acosta Jr., enjoyed living in beautiful places. A childhood spent on the southern California coast and in the southern Sierra Mountains was a beautiful gift.

Thank you to my husband's parents, Norman Barna and LaRay Martyn Barna: Not only did you raise a marvelous son, but your steadfast support this past decade has helped me more than you know.

To my many art teachers throughout my life, especially Edward and Maxine Runci, Douglas Campbell Smith, Michael Kelly and Frank Okada: Thank you.

I am thankful to all of my family and friends, past and present; in one way or another, you have helped me to become the artist I am.

During the course of writing this book, many people were directly helpful. Thank you to...

Deanna (Dee) Hansen: Not only did you help me begin this book, but your life is a wonderful example of love and generosity.

My sisters, Alisa Acosta and Teresa Acosta: I am blessed to have you as my lifelong friends and soul mates.

Katy Graves Yoder, my beautiful friend, for your support and involvement.

My friend Gary Alvis for not only taking great pictures, but setting me up to do the same as I wrote the book.

Kevin Kubota, Loren Irving and Brian Orlov for your artistic photos.

Suzanne Schlosberg: You have a generous heart.

Daniel Smith, Inc. for generously supplying the paints and brushes I used in the book.

My editors at North Light Books: Rachel Wolf, thank you for believing in this book and getting me started; and a big, big thank-you to Stefanie Laufersweiler: Your sensitive editorial style and personal vibrancy have made this book a pleasure to write.

My art is created from my entire lifetime of experience. Each image is the answer to a prayer. As a young child I prayed to God for visions. Now that I have grown up, I realize that my prayers have been answered, and for that I am most thankful.

Dedication

To my loving husband, Randall Barna,
and our daughter, Isabella Pilar:
Thank you!

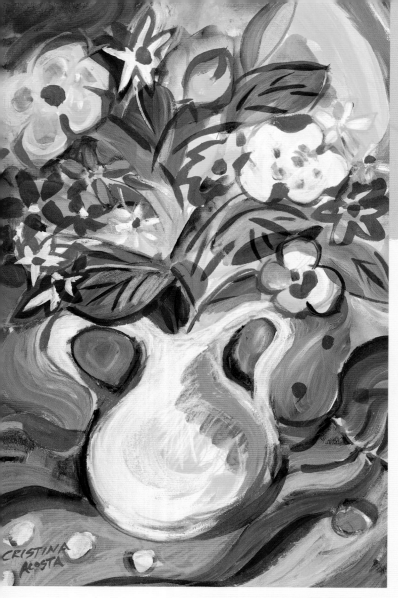

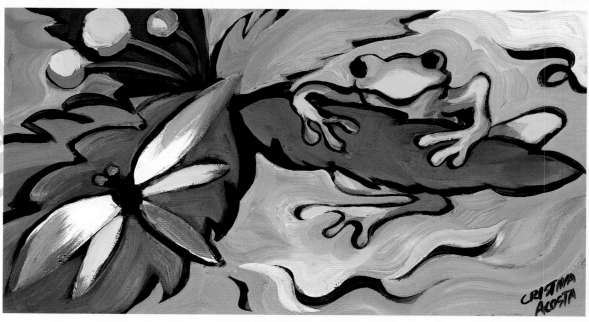

Table of Contents

Find out what supplies you need to get started, including paints, brushes and pastels, plus a few unusual materials. Then you'll warm up and get accustomed to your painting supplies and learn the basics of mixing color.

In this section you'll learn how to design good paintings by using various concepts: variation and repetition, rhythm and movement, shapes and sizes, color and value balance, and space. Examples and demonstrations will show you how to see these concepts in paintings and put them to use to create beautiful, fun art.

Move beyond your easel and into your home: You can paint tiles, ceramics, furniture, fabric and even walls! Many examples and a step-by-step mural demonstration show how you can paint your home happy.

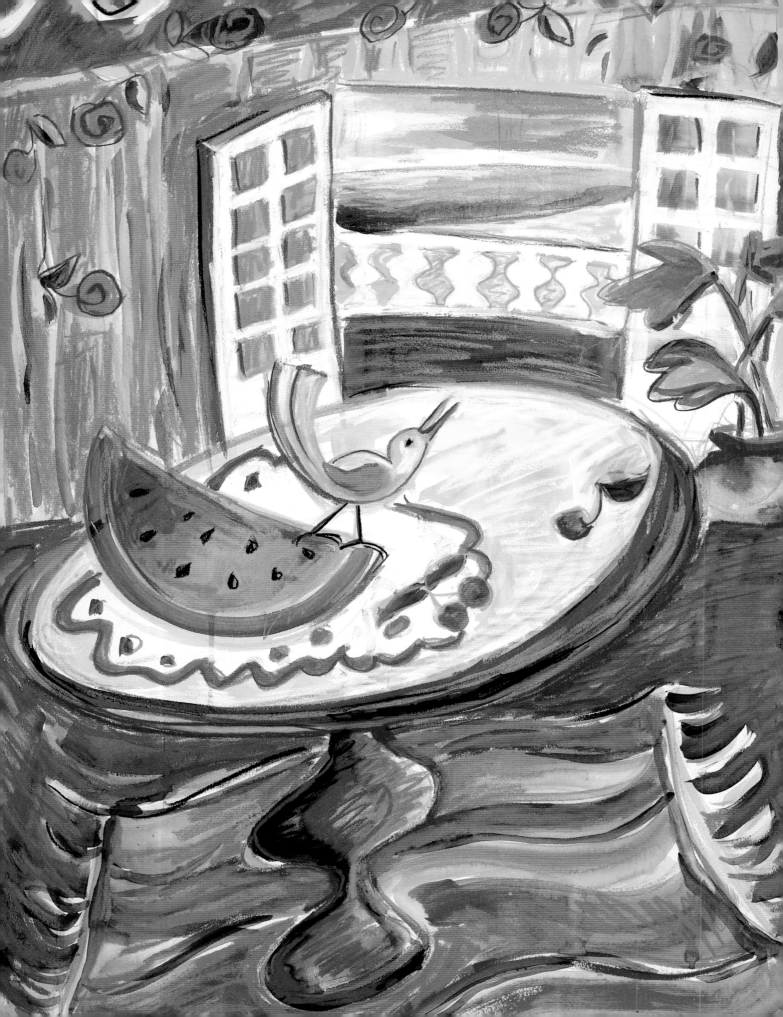

I painted for many years before I realized that I was chasing a myth. Somewhere along the way, I came to believe that to become a good artist, I needed to acquire an ever increasing knowledge of methods and techniques. My attention to technique garnered me a job as the production artist for a billboard company.

After a couple of years painting billboards, I could copy any image given to me in any style, from simple cartoons to photo-realism. By that time, the holy grail of technique seemed disappointingly empty. I had given nearly all of my attention to developing the skills to paint whatever I wanted and very little attention to discovering what I really wanted to paint.

For a few years, I taught college drawing and painting classes. While the students gained "the basics," I noticed that for most of them, consistent academic study didn't seem to encourage innate joy and enthusiasm for painting. I knew that if I didn't teach any basics my students would be adrift, eventually becoming frustrated by their lack of ability to correctly mix the colors they needed or to understand what they saw in a painting. I thought that there must be some way to teach artistic skills without getting in the way of a student's unique vision of the world.

Surprisingly, my epiphany came with the experience of motherhood. By the time my daughter, Isabella, was eighteen months old, she was painting every day with me. Watching her, I couldn't help but notice that her experience of painting was entirely different from mine. She painted with complete abandon. She was never hard on herself. In fact, when she finished a painting that she really liked, she'd put her brush down and clap and cheer! If she didn't like it, she quickly pushed it aside and moved on. She never tried to paint like anyone else (especially her mother!).

Whenever Isabella finished a painting, she would show it to me. I'd look at the piece and very clearly tell her what I admired about it. Her natural style of learning augmented with my minimal positive insights enabled her to learn quickly and define her own style.

During Isabella's toddler years, I was so inspired by her obvious happiness while creating that I decided to take an hour or so each day and paint in the same fashion. The more I opened my mind to painting with the attitude of a child—albeit a very "experienced" child!—the more my work evolved. Within a few months, my style of painting had completely changed. My work flowed so naturally that the images seemed to paint themselves. I became passionately excited to rediscover that creating could be so simple. My images reflected my joy, and "paint happy" was born! Learning to paint happy was the key that opened my creative soul.

Whether you're a new painter or an experienced artist looking for new energy in your work, you will enjoy learning to paint happy. My book guides you to connect with your playful inner spirit while you learn the basics needed to become technically proficient.

I don't intend for you to permanently paint images in my style. My style is the result of my particular life experiences. You may wish to copy my exercises as closely as possible, then, taking what you've learned, immediately create an image of your own. With practice, your innate sense of design and personal style will develop.

So open this book and enter a world of color. Follow along with your paintbrush in hand, and chapter by chapter the beauty of the world around you and within you will be revealed through your painting.

Enjoy!

Cristina Acosta

Sunny Morning • acrylic and pastel on paper • 30" x 22"
(76cm x 56cm) • photo by Gary Alvis

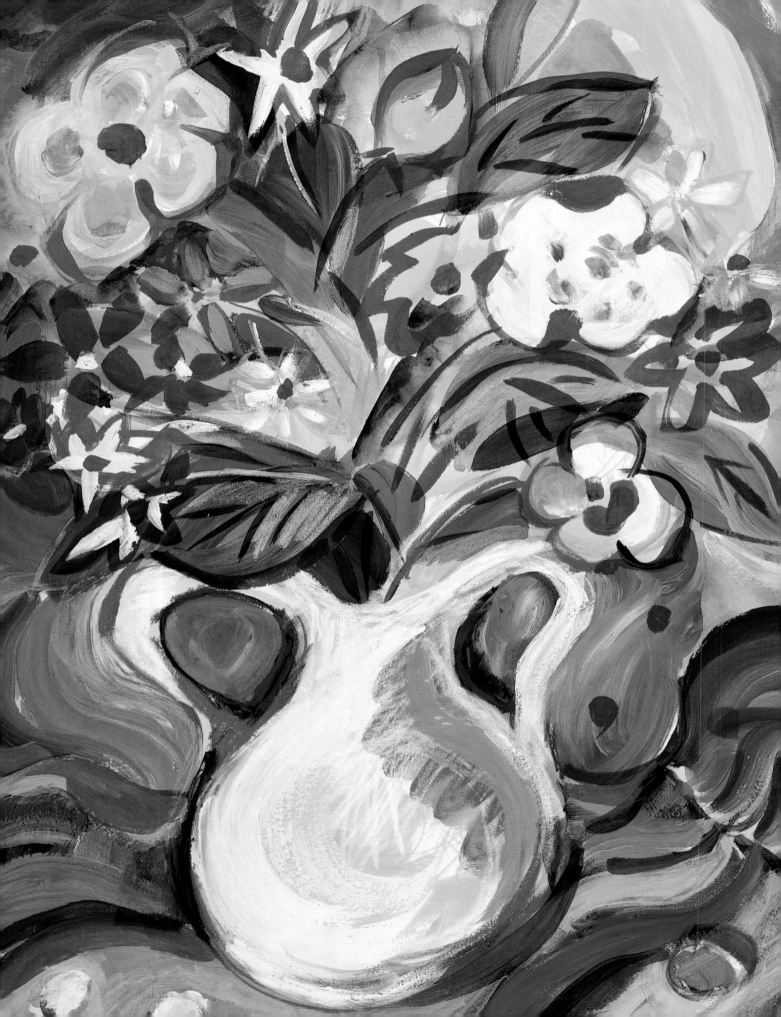

Getting Started

Everyone is an artist. You have a gift. Some people realize it at an early age, and some people find their gifts in adulthood. Even if you have never been encouraged to be an artist, you will soon realize that you are truly creative. Your journey into painting has begun, and getting started well will put you on a road of infinite possibilities.

Follow along with the next few chapters, and I will introduce you to the basics you need to enjoy the process of painting. You'll warm up by playing with paint and other fun materials. Then you will begin to learn about color.

Garden Vase • acrylic and pastel on paper • 25" x 17" (64cm x 43cm) • photo by Gary Alvis

Materials

Sometimes you'll get an idea for a painting and know that you need to get it on paper or canvas as soon as possible. Being able to create easily enables your ideas to flow freely from you. Eliminate the hassle of setup time and you establish a place in your life for your creativity to flourish.

Make your first creation your workspace. If you're able to devote a room or section of a room to a permanent studio, that's great! If you can't, then begin by making life easy on yourself. Find a closet or corner where you can store your art supplies. Buy a set of stacked plastic drawers on rollers. Keep your supplies organized and ready at a moment's notice. Arrange your drawers by grouping your supplies; for example, keep all drawing materials in one drawer, acrylic paints in another, safety equipment in another, and so on.

Workspace items you need are:
- folding card table or other table
- easel (the best you can afford)
- drop cloth
- water bucket
- rolling drawers
- trash can
- adequate lighting (preferably color balanced)

From the moment the first person drew with a burnt stick on a cave wall, humans have been making art with whatever they can find. We're going to start out with traditional materials—paints, pastels, brushes, pencils and papers. Throughout this book, you will paint with acrylics and draw with pencils or hard pastels. Buy the best-quality artist materials you can afford.

Drawing tools

You should doodle or draw rough ideas for your paintings. Store some soft pencils (2B, 4B and 6B) and a white plastic eraser in your supply drawer. Keep some assorted markers on hand for the same purpose.

Keep handy a set of hard pastels with a minimum of twenty-four colors. Use them to draw on your paper before you begin a painting. Start with a light color. When the drawing is just what you want, switch to a darker pastel that's easier to follow. Vary your marks using the sides or points of the pastel. You will find that you can create a variety of strokes. Spray your drawing with fixative to control smearing, whether it's a finished piece or an initial drawing before applying paint.

Sometimes you'll use pastels with acrylics as you develop a painting or apply finishing touches. To avoid smearing the finished product, spray these pieces with fixative.

Prismacolor Nupastel hard pastels come in a variety of colors. Hard pastels are firm and create very little dust.

Practice making a variety of marks and lines with your drawing materials. Contrast thin lines with thick lines, consistent marks with inconsistent marks, and experiment with smearing your strokes.

Paints

Using Acrylics

Acrylic paint has some wonderful advantages. It cleans up with water, doesn't stink, adheres to a variety of surfaces including fabrics, and you can make changes very quickly as you paint.

This medium also has a challenging side. Acrylic paint dries very quickly, which can require some planning if you blend edges. Color matching takes some practice because the colors dry a little darker than they appear when wet. All of your practice will pay off. After you learn to paint with acrylics, you will be able to transfer your color-mixing skills to any other type of paint.

Acrylics dissolve in water until they dry. Once dry, they are permanent. Acrylic paint will stain your clothes and carpet permanently. Consistently use a drop cloth and wear an apron or painting shirt to minimize any messes and damage.

General supplies you need for painting are:

- plastic palette with airtight lid
- large spray bottle (to mist the paint palette)
- paper towels or cloth rags for cleanup
- acrylic gloss painting medium (mixes with paint to create transparent glazes)
- acrylic flow release (mixes with paint and water to create a watercolor-like effect)

Colors

Quality paints are strongly pigmented and go farther than student- or economy-grade colors. These are the colors I use:

- Anthraquinoid Red
- Black (I prefer Lamp Black)

Always buy the professional grade to ensure you are learning with the best-quality paint. Student-grade colors are often not made with the same pigments or density of pigments. Use any brand of paint that you prefer, as long as you consistently use the same brand until you completely understand color mixing. Colors can vary between brands, and switching brands may confuse you.

- Buff Titanium
- Cadmium Red Medium
- Cadmium Yellow Medium
- Cobalt Blue
- Dioxazine Purple or Carbazole Violet
- Hansa Yellow Light
- Pearlescent Shimmer
- Permanent Green
- Phthalo Blue (Green Shade)
- Phthalo Green (Blue Shade)
- Pyrrol Orange or Cadmium Orange Medium
- Quinacridone Gold
- Quinacridone Magenta
- Quinacridone Sienna
- Ultramarine Blue
- White

There are quite a few theories about how many colors an artist really needs. You can mix orange from yellow and red, but you do make your life easier when you use Cadmium Orange or Pyrrol Orange instead. Then there are the colors that are just far more appealing out of the tube than you can ever hope to mix: Quinacridone Magenta gives you beautiful clear pinks; Dioxazine Purple and Carbazole Violet are gorgeous. When you need black, using a tube of black is far easier and less expensive than mixing black by combining several colors.

Technology is continually changing our world and our paints. New lightfast colors—"lightfast" meaning resistant to fading or changing over time—are replacing less lightfast colors. Anthraquinoid Red replaces the less lightfast Alizarin Crimson. Buff Titanium gives you color-mixing options not available with plain white.

So buy what you can. Having a variety can make color mixing much easier for you. If you like a color that's not on the list, use it; you'll have more fun.

Brushes *and* palette knives

Brushes are made for every medium, use and price range. A good starter set of brushes for use with acrylics has a variety of shapes and sizes. Synthetic bristles will give you the longest wear.

Here's what you'll need to get started:
round nos. 2, 4, 8 and 12
flat nos. 4, 8 and 12
bright no. 6
two palette knives of different
shapes and sizes
brush washer or bucket of water
acrylic brush cleaner (option: soap
or mild detergent)

If you can, buy two sets of your favorite brushes. As you paint, use one set of brushes for light colors and one set for darker colors. You will minimize your brush-washing time and reduce the likelihood of contaminating colors on your palette.

You'll find that certain brush sizes and shapes quickly become your favorites. I tend to like rounds and flats best, but I'll usually choose a brush by looking for the size I want among whatever brushes tend to be closest and

cleanest. Often I'll paint an entire painting with only two brushes—one large and one small. Sometimes I'll use up to a dozen brushes if I am doing a large piece with a variety of colors.

Here are a few tips to keep your brushes supple and shapely:

- Wet the brushes before you put them in paint. This makes for a cleaner ferrule (the metal sleeve that holds the bristles to the handle). Dip them in water or acrylic medium.
- Don't let a brush sit for very long on its point in the water bucket.
- Use a professional brush-cleaning solution in the rinse water.
- Be sure to wash your brushes after each painting session. If you forget

a brush and it hardens, use full-strength acrylic brush cleaner to work the paint out.

Consistently care for your brushes and they should last at least a year or more. Buy a brush of the very best quality you can. A responsive brush that holds its shape and springy quality will serve you well.

Painting knives come in various shapes and sizes. You will use them mostly for color mixing. An inexpensive knife is adequate. Look for knives that are rust resistant.

Surfaces

Use high-quality rag watercolor, drawing or printmaking papers, minimum 90-lb. (190gsm) weight. Most of my paintings are done on paper that is 20" × 30" (51cm × 76cm) or smaller. Watercolor paper surfaces are described as *hot press* (a smooth, sometimes shiny surface), *cold press* (slightly textured) or *rough* (more heavily textured). If you use watercolor paper, cold press will yield results most similar to the lessons in this book. Experiment with different surfaces to see what you like.

When you create a collage, use Masonite or any smooth wooden panel or stiff board. Use ⅛" (3mm) thickness for pieces under 12" × 12" (30cm × 30cm) and ¼" (6mm) thickness for anything larger.

Buy two tablets of acid-free sketch paper: a larger tablet up to 22" × 30" (56cm × 76cm), and a smaller size, 3" × 5" or 4" × 6" (8cm × 13cm or 10cm × 15cm), to carry with you.

Shown are white Rives BFK printmaking paper, pale blue Magnani Pescia paper and black Rising Stonehenge paper. Choose paper that is heavy enough to tolerate water and the action of drawing.

Buy a small sketchbook that's easy to carry in a pocket or purse. A larger tablet will come in handy for your studio sketches. Spray fixative will keep your drawings from easily smearing onto the other pages of the tablet. A white plastic eraser will allow for neater erasing.

Tip

Always use decent paper. Newsprint and other papers high in acid content quickly disintegrate. You never know when even a quick sketch will be one of your best pieces.

Other fun materials

Pick up some unusual items and use them for some of your projects. Working with an unfamiliar medium opens your mind to new images. You won't have a basis to worry if you're doing it "right." There is no right or wrong way to draw a smiley face with a caulking gun or a bouquet with glitter glue!

Remember making collages in grade school? We used dried beans and colored egg shells. Take a look around your home to find something interesting to work with, or take a shopping trip.

The hardware store is a great place to start looking for out-of-the-ordinary art supplies. Have you ever wondered what it would be like to draw with a caulking gun or asphalt tar? If you love exploring various nontraditional materials, indulge yourself. Be adventurous! Try caulk, tar, concrete, carpenter's chalk or spray paint.

If you like gold glitter, buy it by the pint! Be generous. Surround yourself with a wealth of supplies, and every mark you make will come from a sense of abundance.

Each medium produces a different mark on the paper. The possibilities and restrictions of different kinds of materials will lead you to new artistic discoveries. Pictured are glitter, polyurethane spray paint, a caulking gun and a variety of metal leaf sheets. Polyurethane spray paints come in clear coats and a variety of colors, including metallics.

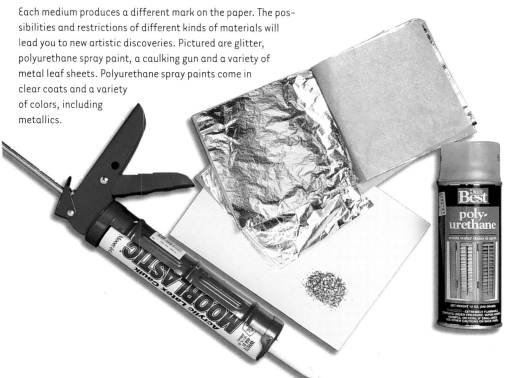

Safety Tips

Work in a well-ventilated room. If you can afford it, use an air filter (I have a HEPA filter). Keep your safety supplies close at hand so you won't be tempted to work without them "just this once." Have these items handy:
- disposable vinyl or latex gloves
- hand-protecting barrier cream or lotion (if you don't like wearing gloves)
- disposable dust masks (if you are sensitive to pastel dust)
- apron

If you choose barrier cream instead of gloves, remember to reapply the cream after wetting your hands. Also, *never* eat or smoke while you are working with pigments.

This painting, *The Communion of Saints II*, was created with charcoal, marker, caulk and spray paint on a 3" x 5" (8cm x 13cm) piece of red velvet.

Let's Play!

No matter what your age is, you learn easily while playing. When you play, you concentrate easily, your mind relaxes, and you enter a state of flow—the perfect place to learn.

As responsible adults, it's easy to find excuses to put off our artwork. Most of us blame it on a lack of time. Who has time to play? It's important to set aside even five minutes in your day to create. Make a habit out of making some sort of art every day—even if you only take a moment to rearrange the food on your plate! Better yet, sit down with a child and have a drawing or painting session. You may be surprised by what you can learn from a child.

Grab your art supplies and practice the exercises on the following pages. The exercises are simple enough to get you moving, and they'll give you a chance to get comfortable with your paints and other supplies.

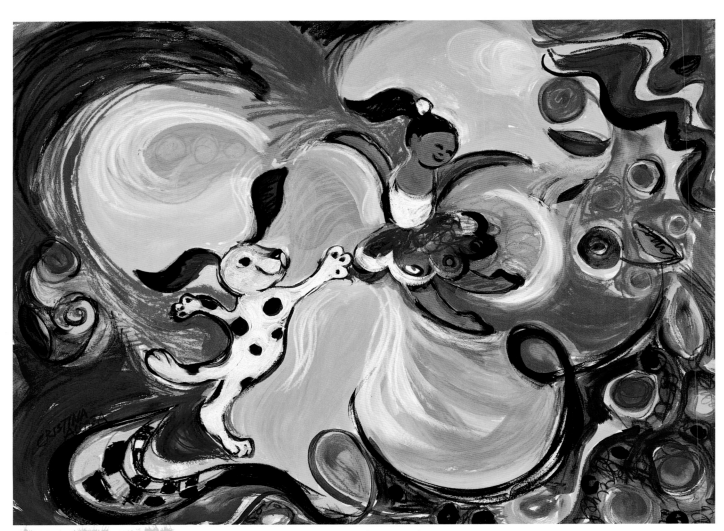

Bella and Her Puppy · acrylic and pastel on paper · 21" x 28" (53cm x 71cm) · collection of Patti Johnson · photo by Gary Alvis

Two hands are better than one

Let's start by getting a feel for drawing. Two-handed drawing is a simple way to create a symmetrical design. It is also a good warm-up exercise to put you in an artistic frame of mind.

Begin your artwork by thinking about the shape of a vase and the shapes of flowers. When you make up a design, it's not necessary to think of specifics, or exactly how a bouquet or particular flower looks. I find that when I hold the thought of the subject in my mind, my artwork stays on track.

Two-handed drawing takes concentration. When you draw, focus your eyes either on just one hand or somewhere between both hands. Relax and move your hands with consistent thought. Let your drawing be as quirky or perfect as it happens. If you find your mind wanders, repeat the word *flower* silently to yourself to enhance your concentration.

Don't erase, and always move both hands at the same time. Don't worry about your drawing abilities. You'll be drawing with both hands, so you'll be twice as good!

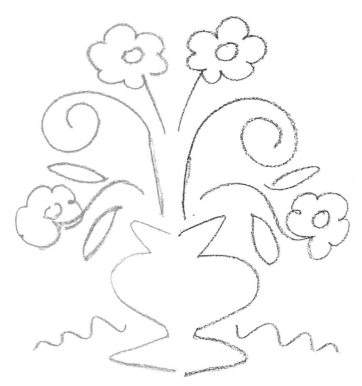

Hold two different-colored pastels, one in each hand, as you draw on a piece of paper. Start with a simple vase shape, then begin drawing the flower shapes. Keep the drawing as symmetrical as you can. Whenever one hand moves, so does the other.

Begin another drawing. Change the colors of the pastels as you draw the various flowers. Let your flower and leaf shapes swirl over the paper.

Draw several sketches. Vary the subject. Anything that is suited to loose symmetry will work.

Paint with both hands

materials

Paper ✳ minimum 90-lb. (190gsm) weight

Brushes ✳ no. 2 and 4 rounds

Acrylic Paints ✳ Black ✳ Cadmium Yellow Light ✳ Carbazole Violet ✳ Hansa Yellow Light ✳ Permanent Green ✳ Phthalo Blue (Green Shade) ✳ Pyrrol Orange ✳ Quinacridone Pink ✳ Ultramarine Blue ✳ White

Other ✳ tape ✳ hard pastels (yellow and orange) ✳ acrylic medium ✳ palette knife ✳ spray fixative

Painting with two hands is a little sloppy and uncontrolled. You can't be exact and careful, which makes this a great way to learn to paint. Using both hands is a good way to begin any artwork. Your brain quickly slips into a visual mode when both hands are engaged.

This fun birthday cake painting celebrates rhythm and color with simple exuberance. You learn to work with color and paints in a relaxed, messy style that completely excludes perfectionism!

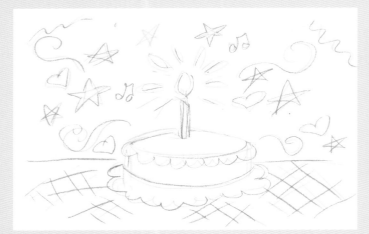

1| Make a Drawing

Tape down the paper. Create a simple drawing with large shapes. With a yellow pastel, start drawing the cake shape. Fit the stars and swirls around it, drawing symmetrically with pastel. When you have a drawing you like, draw over the yellow lines with an orange pastel.

Spray fixative over the drawing to prevent smudging.

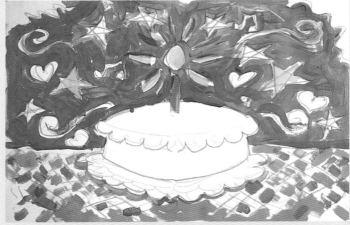

2| Start Painting Larger Areas

Holding a brush in each hand, begin with the background. Mix Ultramarine Blue and White together with your palette knife. Pour about a tablespoon of acrylic medium near the color. Dip each brush in water, then in the blue mixture. If the paint seems too dry, mix in a little acrylic medium. Paint the larger spaces first, working symmetrically.

Begin painting some of the details with Cadmium Yellow Light and Pyrrol Orange.

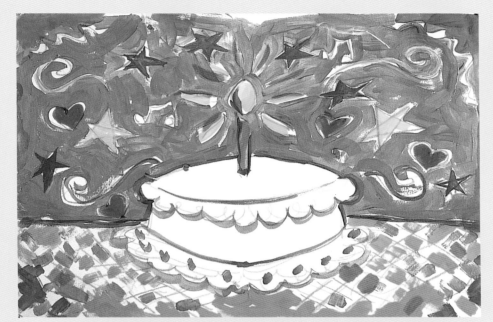

3| Add More Colors

Continue adding color to your painting. When you change colors, pour a teaspoon or so of acrylic medium near the paint. Mix small amounts of color to reduce wasted paint. Concentrate on moving both hands identically. The heart shape is especially fun to paint with two hands. Start at the top dip of the heart, then move both brushes to the bottom point.

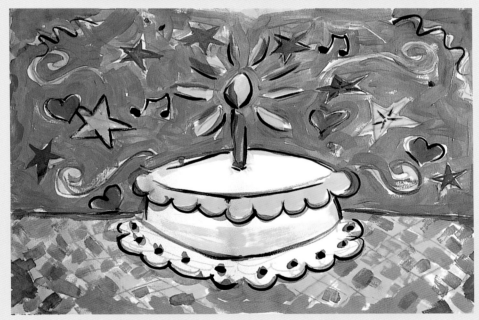

4| Finish

Mix Hansa Yellow Light with acrylic medium, and then paint this thin mixture over the tablecloth and other dry areas of the painting. This is called *glazing*—painting over a dry layer of color with a transparent or semitransparent layer of another color. This enhances the base color by giving it depth. If the glaze color is similar to the base color (like yellow over orange), the base color will brighten. If the glaze color is a complementary color (like green over red), the base color will deepen and become slightly more neutral. Hansa Yellow Light is a transparent yellow that makes a wonderful glazing color.

When you are done with the paints, reinforce your drawing with lines in yellow and orange pastel and black paint.

Tip

Change colors whenever you sense the urge to change. If you are in the middle of a stroke or shape and the slightest urge to change color crosses your mind, do it. Don't stick with a preconceived plan for your artwork. If you're halfway through painting a star yellow and the color purple comes to mind, bring out the purple!

If a color looks a little strong, lighten it by adding a little white or Buff Titanium.

Make a puzzle-piece drawing

Tip

Don't spend too much time on a drawing. Do many drawings rather than working one or two to death.

Are you ready to draw with only one hand? I call this "puzzle-piece" drawing because you link all of the shapes you create with each other and the sides of your paper. The finished shapes look like puzzle pieces. Notice how an image is really just an arrangement of related shapes within a larger shape.

Follow along with my drawing, then try a few drawings of your own. All you need is some paper and a handful of colored pastels.

1| Begin Drawing Connecting Shapes

Start with a light-colored pastel. Begin with the vase shape; then connect it to the table shape, which you connect to the edge of your paper. Now add leaves and flowers, connecting at least one of those shapes to the window shape. Further divide the large table shape with a cloth and a fallen flower. Let shapes go to the edges of the paper.

2| Delineate Shapes

I made several attempts at different lines before I found what I liked. Once you like a drawing, firmly delineate the shapes with a strong-colored pastel.

3| Make Adjustments

Look over your drawing and see if your eye gets stuck on any particular part of the image. Adjust any such areas by either adding connecting lines or removing them.

Now you can make a painting based on your drawing.

Make a puzzle-piece painting

materials

Paper ✳ minimum 90-lb. (190gsm) weight

Brushes ✳ no. 4 and 8 rounds ✳
no. 8 and 12 flats

Acrylic Paints ✳ Anthraquinoid Red ✳ Cadmium
Yellow Light ✳ Carbazole Violet ✳ Permanent
Green ✳ Phthalo Blue (Green Shade) ✳ Pyrrol
Orange ✳ Quinacridone Gold ✳ Quinacridone
Pink ✳ Ultramarine Blue ✳ White

Other ✳ hard pastels (one light
and one dark)

Now you will simply color the shapes you've drawn. Shapes interlock with each other across the surface of your picture. The color you choose to paint a shape either helps it to stand out from the other shapes or lets it blend in with the others. A variety of shapes in your painting makes your image more interesting.

As you paint the shapes of your drawing, pay attention to how a color feels. Ask yourself what that color's personality is. If the color were a person, would it be hyper or quiet, assertive or passive? Pay attention to your sensations about color, and you will quickly become a proficient painter.

You probably had some experience with coloring books when you were a child. Puzzle-piece painting is a natural extension of this activity. It's that easy!

1| Make a Drawing

Choose your favorite puzzle-piece line drawing or make a new one on good-quality paper with pastels. When you begin drawing the shapes, think about varying the sizes. Create areas with large shapes. Divide the background into several shapes. Develop a cluster of smaller shapes in one part of the picture to create a focal point, as I have done here with the flowers and leaves.

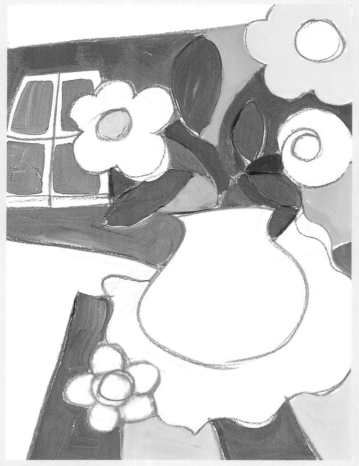

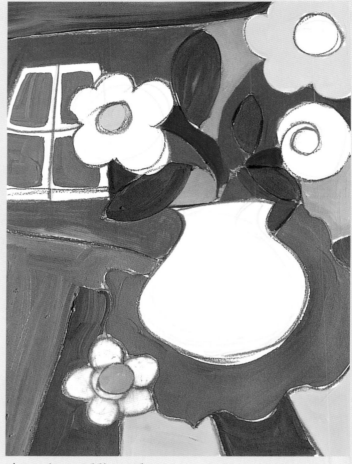

2| Begin Painting

Paint with any colors you like. Start painting the large shapes with a no. 8 round. Use a no. 4 round to paint the small shapes. Paint different colors next to each other, maintaining the puzzle-piece shapes. When colors are too strong directly out of the tube, mix them with white.

I painted the background with different reds and oranges. The red colors are similar enough to create a unified background, yet different enough to create lively interest.

3| Continue Adding Colors

Continue to add colors, keeping in mind how they relate to each other. On the table, I repeated the colors of purple and blue used on the ceiling and window because I wanted to emphasize the flat pattern of the design. Bringing the color from the background wall (or back plane) to the front table (or front plane) minimizes the perceived distance between both planes and effectively "flattens" the image so that the design of the shapes is dominant.

Tip

Where shapes seem too big, break them down into smaller shapes.

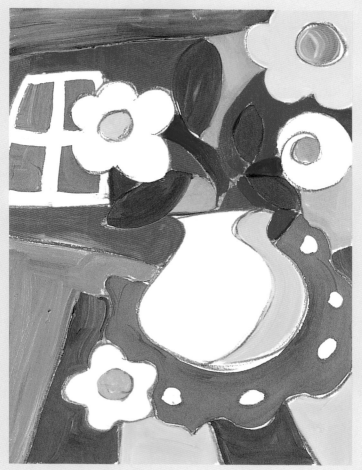

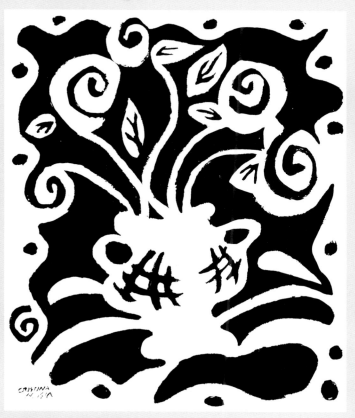

4| Finish

Finish by fine-tuning your painting and correcting what you don't like. I added white dots to the blue cloth and a yellow shape to the vase because its white shape was too large. I thought the yellow was getting a bit too dominant in the painting, so I changed the flower center on the table from yellow to pink. I painted over some of the lines I had left from my original drawing, and made the rest of the flower centers pink. This encouraged my eye to travel around the painting without getting stuck on any particular spot. When I look at a painting, I want to feel my eyes moving easily around the image, lingering here or there, then moving on.

Try a Black-and-White Painting

To focus more on shapes than color, create a puzzle-piece painting in black and white. Play with connecting and separating the white and black shapes so that they are various sizes. In this example, the shape of the white vase was too strong. My eyes kept getting stuck, looking at it more often than other parts of the piece. To keep the vase from overpowering the other parts of the painting, I broke it up with a grid pattern.

Tip

Remember to spray your palette with water regularly so your paints stay moist.

Create a puzzle-piece collage

materials

Paper ✳ one sheet of 16" x 19" (41cm x 48cm) heavy black paper ✳ several sheets of 11" x 17" (28cm x 43cm) white paper (office-supply grade) ✳ assorted colored papers

Other ✳ pencil ✳ eraser ✳ scissors ✳ glue stick or acrylic medium

In this demonstration, you will learn more about different ways to use shapes by creating a colored-paper collage. Start with a puzzle-piece drawing and let your imagination run. You cut up the shapes and put them back together—just like a real puzzle!

1| Make a Rough Drawing

Copy this drawing of laundry on a line onto 11" x 17" (28cm x 43cm) paper. Don't worry about being exact.

2| Refine Drawing and Plan Colors

Now trace over your first drawing, redrawing and refining the shapes as necessary. With your colored paper in front of you, plan your color placement. Label each shape as to which color to use. This copy is your pattern.

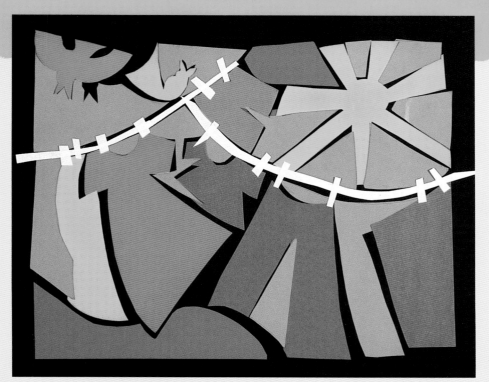

3| Cut Out Shapes and Place Them

Cut out the colored shapes according to your pattern, starting with the largest, least complicated shapes. Assemble the pieces on your black paper. The black paper background is now the negative space. The colored paper cutouts will collectively become the positive space. Adjust the puzzle pieces of your collage to show the background.

Play with making the negative spaces different widths. When you are satisfied with your design, glue down your collage. For the laundry line and clothespins, cut little strips of white paper and glue them on last.

4| Complete With Smaller Shapes

Embellish the large shapes of the collage with various patterns of smaller shapes.

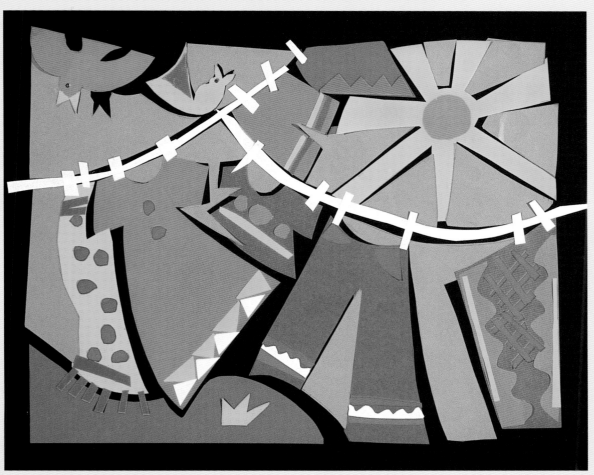

Use unusual materials

You don't have to use paint to create great art. Sometimes nontraditional supplies can be more fun and a much needed break from the norm. In this exercise, you'll emphasize the puzzle-piece shapes with various textured and colored materials.

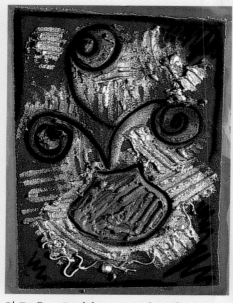

1| Prepare the Surface

Spray gold paint on Masonite or another sturdy surface, then glue on a piece of red velvet. The gold surface will create a frame for your image. Transfer one of your drawings to the board with a light-colored pastel. I chose a flower drawing.

2| Add Texture With Mortar

Mix thin-set cement mortar with acrylic medium to the consistency of cooked oatmeal. Spread the mixture on the velvet with a V-notch trowel, and make some designs with your finger or the handle of a brush while the mortar is still wet. Allow the mortar to dry. Drying time depends on temperature and humidity; one to three hours is usually enough.

3| Define Positive, Negative Shapes

When the mortar is dry, use caulk to create a squiggle along the bottom of the vase. Now, try some negative painting—use gold spray paint to cover the background shapes around the vase and flowers. Use a black pastel to define the positive shapes—the vase and its flowers.

Design shapely connections

Varying the size and complexity of shapes makes your image interesting. This tracing exercise probably won't result in a drawing you'll hang on your refrigerator, but you will learn to manipulate shapes on your paper and gain some expertise with your pastels. Practice creating designs with a variety of shapes using the objects around you.

Collect several objects—nothing larger than your paper—that have easily recognizable shapes when traced. Look for items of various sizes and complexity: your hands and feet, scissors, a wooden spoon and fork, a screwdriver, a wrench, cookie cutters, paintbrushes and so on.

Tracing gives instant gratification—draw some lines, and there is something recognizable on the paper! Is that cheating? No, because you're going to use your tracings to create your own designs. Tracing takes the stress out of drawing, so you'll be able to focus your full attention on your design.

Try This!

For your first drawing, you may want to use only black pastel. Vary the use of your pastel by using line in some parts of the drawing and smearing in other areas. Use an eraser to fine-tune the white areas of the paper. Experiment with partially or fully filling in some of the shapes.

Pictured is a good variety of everyday objects to use for this exercise.

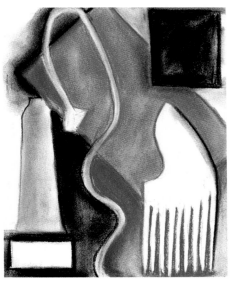

Begin by tracing your objects in pencil onto a piece of paper. Play with grouping the shapes, overlapping them and running them off the page. Do a couple of drawings using different items to trace. Vary the size and type of the objects you choose. Include simple and complex shapes.

Next, color areas of your drawing. Limit yourself to three colors of pastel and black. You might use an eraser as a drawing tool, too.

Use a photocopier or another method to enlarge a portion of your tracing. Use black and only a few colors to create a few more drawings. Play with filling in the negative shapes (spaces around objects) and positive shapes (the objects themselves) in alternating patterns.

 Tip

When you change colors, you may have some trouble keeping different-colored areas from contaminating each other. Spray your drawing with workable spray fixative as you work to keep things clean. You can still use your eraser after applying fixative.

Paint like *a* child

My daughter, Isabella, began painting with me when she was a toddler. I'd strip her down to her diaper, set her on my worktable with nontoxic paints and let her play. Paint went everywhere! When she became particularly pleased with her work, she'd put her brush down and clap.

Young children learn by playing and exploring. Spend some time painting with a young child. Observe the ease with which they create. Visualize yourself painting with the same sense of abandon, then do it!

Birdbath · Isabella Acosta Barna, age 5 · acrylic on paper · 5" x 7" (13cm x 18cm)

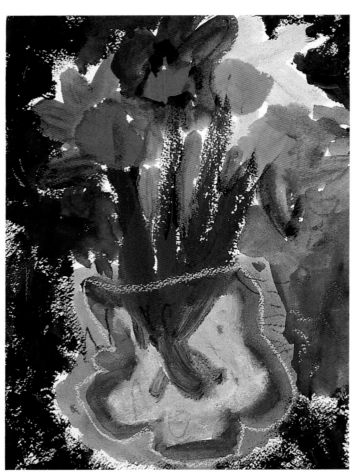

Spring Flowers · Isabella Acosta Barna, age 5 · acrylic on paper · 7" x 5" (18cm x 13cm)

Tip

Visual symbols are often found in doodles, children's work and anywhere people want a quick visual to communicate an idea. Use symbols as ideas to start a painting.

Use your imagination, *then* start small

A child usually paints from her mind's eye rather than re-creating a subject in front of her. Your memories and imagination feed your mind's eye. Memories are a distillation of your experiences, and your imagination grows from those experiences. Painting from your mind's eye automatically conveys your unique perspective.

Begin your artwork thinking of the images that are within you—not in front of you. Give yourself a few minutes, then start. Paint any shape, line, color or image that comes to mind. If you are thinking only about making dinner, then start painting food! Start your hand moving, and your ideas will follow.

You may wonder how to correctly paint something. Maybe you've thought of a bird sitting on a chair. Stop and think about why you remember that bird. Do you recall its song, the way it flew, its particular personality or an incident that involved the bird? Concentrate on those things and you can paint your bird.

Start small. All the images on this page are postcard size. Think of these as color sketches. You may like one of yours enough to use it as the basis for a larger painting.

Color Mixing

The fun is over! Well, not really, but you are going to put it on pause and learn some color mixing. Whatever you do, do *not* skip this chapter.

Think of any tedium you experience as an investment that will pay off a hundredfold. Learning to mix color is like learning to type: If you practice it enough, it becomes an unconscious skill.

Setting up your palette is the first step. Arrange the paints close to the outside edge of the palette in color-wheel order, as shown in the picture. For colors that don't specifically fit on the color wheel—Quinacridone Gold, Buff Titanium, Pearlescent Shimmer and black, for example—place them together on a short end. Also, if you have a color that isn't part of the supply list, put it either on a short end or near a similar color. Squeeze out two piles of white: one next to yellow and one next to blue. Mist the entire palette with water and close the lid until you're ready to paint.

As you gain experience, you may want to rearrange some of the colors to suit your personal preferences. Whatever you choose to do, do it consistently. Consistent placement reduces hunt-and-peck time considerably.

Use a canvas tablet to create the following color tools. Keep these finished charts handy for instant reference as you paint. These charts will help you develop an understanding of color mixing. You may look at the chart for a "perfect" color match, but you probably won't find one. What you *will* find is a color that is close to what you want. Remember how you mixed that color, and then adjust your mixture to create your new color.

The color wheel

Making a Color Wheel

The color wheel is the most basic tool you will use to understand the science of color. Placing colors on the wheel teaches you where a color belongs in relation to the others. Referring to your color wheel will help you develop your ability to visualize color mixing. With practice, you will be able to visualize mixing pigments before you even open a tube of paint.

Begin your color wheel by drawing two large concentric circles in the middle of a piece of canvas. Segment the wheel into twelve areas, and label each segment as shown.

Next, thickly apply paint to each area of the color wheel in the order that follows. Keep in mind that paint quality and color differ slightly between manufacturers and that tinting strengths vary. (In other words, your color wheel may not look *exactly* like mine.)

Primary colors. These are the parent hues of all other colors.

- *Yellow*—Use Cadmium Yellow Medium straight from the tube.
- *Red*—Mix together Cadmium Red Medium and Anthraquinoid Red until the red seems perfectly balanced.
- *Blue*—Use Cobalt Blue straight from the tube, or mix together Ultramarine Blue and Phthalo Blue with a tiny amount of white until the blue is perfectly balanced.

Secondary colors. Each secondary hue is made using two of the three primary hues.

- *Orange*—Use Pyrrol Orange straight from the tube.
- *Green*—Use Permanent Green straight from the tube.
- *Violet*—Mix Carbazole Violet with a touch of white.

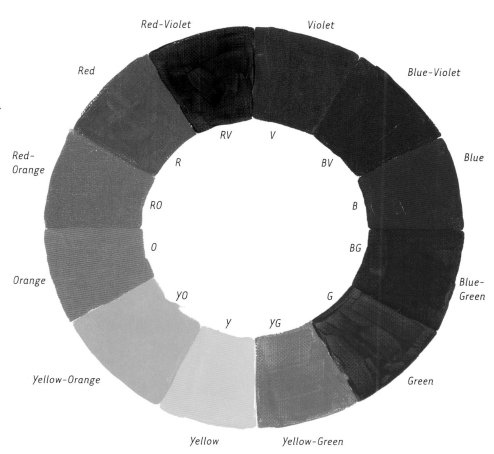

Tertiary colors. Each tertiary hue is a combination of a primary and a secondary hue.

- *Yellow-Orange*—Mix Pyrrol Orange into Cadmium Yellow Medium a little bit at a time until it is the perfect balance between yellow and orange.
- *Red-Orange*—Mix Cadmium Red Medium with Pyrrol Orange.
- *Red-Violet*—Mix Anthraquinoid Red with a touch of Ultramarine Blue.
- *Blue-Violet*—Mix Ultramarine Blue with a touch of Quinacridone Pink.
- *Blue-Green*—Mix Phthalo Blue with a touch of Permanent Green.
- *Yellow-Green*—Mix Hansa Yellow Light with a small amount Permanent Green.

Tip

Put a little petroleum jelly in the groove of the palette lid to ensure an airtight seal. Remember to lightly spray your palette with water before sealing the lid. Paints will remain fresh for your next painting session.

Color Relationships

Draw a line from one color on the color wheel across to the color exactly opposite. The opposite color is called a *complement*. The two colors adjacent to the complement are called *near complements*.

Combining two complements can create a neutral brownish or grayish color. Mixing just a little of one complement with a lot of another complement can cut the strength of a hue so that it is less bright. For example, if you add a little red to a lot of green, the green will change from a grassy green to an ivy green. Adding a near complement to a hue will result in a slightly less dramatic effect.

Colors beside each other on the color wheel are called *analogous* colors. Blue and green are analogous colors, for instance. On a color wheel that includes tertiary colors, blue, blue-green and green are analogous.

The result of mixing analogous colors will always be a variation of the hues you start with. Try mixing the analogous colors of orange and yellow. Without the complementary colors of blue or violet, you are limited to creating colors that are somewhere between a golden yellow-orange and a light yellow-orange.

If you use tertiary colors as part of your analogous color scheme, make sure that the three colors you choose include one primary, one secondary and the tertiary color *between* them. If you choose *any* three adjacent colors on the wheel and disregard that guideline, you may create a neutralized color (you'll learn more about neutrals on page 36).

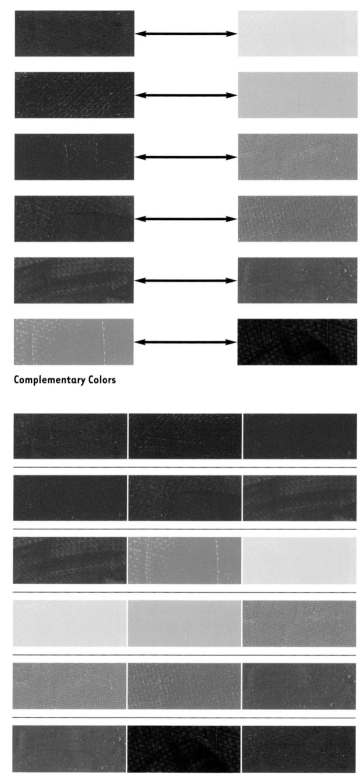

Complementary Colors

Analogous Colors

Creating tints *of* hues

You may have always called these colors "pastels." What they really are, in color-speak, are *tints*. When you mix white with any hue, you create a tint.

Tints are "cooler" than their parent hues. That is why pastels are so popular during springtime: They are the natural visual transition between the cold blues and violets of winter and the warm reds, yellows and oranges of summer. Whenever you mix white with a color, you cool that color. You also lighten its value.

To create a tint chart, mix twelve little piles of each hue you used on the color wheel. Draw the chart below, making sure you have ten empty squares under each hue.

Begin with red. First, paint pure red at the top of the chart. Then add a teeny bit of white, just enough to make it appear different from the pure hue, and fill in the next blank square. Then add a bit more white—again, just enough to make it look different from the previous tint—and so on until you have only a pinkish white at the end.

Continue with one color at a time, moving all the way across the chart. Don't jump ahead of yourself and put all of the hues down first. Acrylic paint dries a bit darker than it appears to be when wet. This would make your color perception a little more difficult.

Don't worry if you can't fill in every square. Note that some hues are darker in value than others, so they have more tints. It's likely that you'll fill the columns of the darker colors such as violet, but not for colors such as yellow.

Color-Speak Guide

Color—Any hue, tint, tone or shade.
Hue—More specific than the word *color. Hue* refers to a primary, secondary or tertiary color.
Tone—Any hue mixed with its complement.
Shade—Any hue mixed with black. Note: Sometimes the words *tone* and *shade* are reversed or used interchangeably.
Tint—Any hue, tone or shade with white added.
Neutral—Any hue that has been toned, tinted and/or shaded.
Value—The relative lightness or darkness of a color.

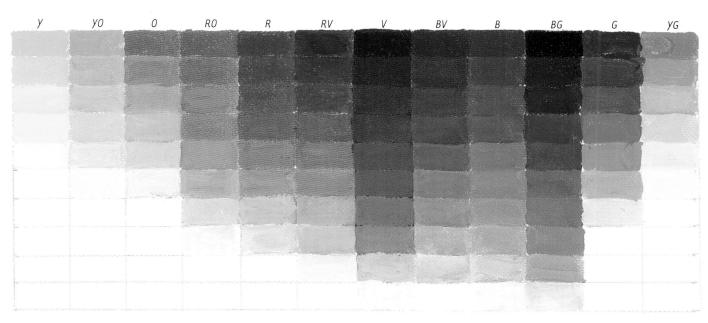

Chart of Hue Tints

Mixing neutrals

You won't always want to paint using only pure hues or tints of hues, so you need to learn how to create neutrals. The word *neutral* usually refers to a color variation of brown or gray created by mixing two or more complements together. However, you can also *neutralize* any hue when you (1) tint it with white, (2) tone it by mixing it with its complement, or (3) shade it by mixing it with black.

We'll begin by creating neutrals that are *tones* of the twelve hues from the color wheel. You'll mix a hue with progressively more of its complement until the result is a neutral color that is neither one of its parent hues.

Start with yellow at the top of the left column and its complement, violet, at the bottom of the column. Now, mix a tiny amount of violet into yellow, just enough to noticeably change the yellow. Paint that in the square below the pure yellow. Then, mix enough yellow into the violet to noticeably change the violet, and paint that in the square above the pure violet.

Repeat this procedure adding even more of the complement to each hue. As you paint the squares, each parent hue should be recognizable, until you come to the middle square in the column. For that square, your goal is to make the middle neutral neither yellow nor violet.

Continue across the chart, mixing complements and adjusting the colors when needed.

Tints of Middle Neutrals

Starting with the six middle neutrals you just made, fill in a chart showing the progression of each color as white is continually added, which will result in beautiful grays.

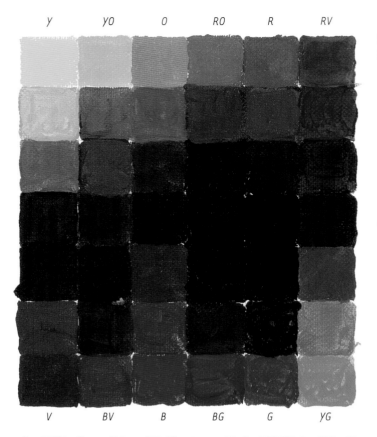

Neutrals Mixed From Pure Hues

middle neutrals

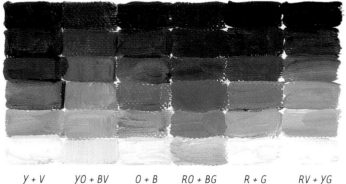

Add White to Middle Neutrals to Make Grays

You may notice that the middle neutrals I started with to create my grays are not perfect matches to the middle neutrals from the first chart. Also, the grays you make may vary from my example. It isn't important for you to make an exact match. The important lesson is for you to become aware of the huge variety of colors you can create.

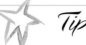

Tip

The term *mud* is often used to describe the neutral colors that appear to drag down a painting. To be fair, neutral colors are not the problem. *Mud* actually describes the artist's muddied understanding of color use. There are no terminally ugly colors; an ugly color is just a color used in a manner that does not fit well with its surroundings.

Is it cool *or* warm? It's all relative

When you understand color well, you can consciously recognize and manipulate the sensations and effects you create with color in your paintings. Developing a keen sensitivity to the relative warmth or coolness of color is a key component of that understanding. Whether you realize it or not, you already intuitively know that each color has properties of warmth or coolness.

In general, warm colors make you think of fire—reds, yellows and oranges. Cool colors make you think of a snow-covered landscape—greens, blues and violets. Look at the color wheel you just painted and you can see that, by comparison, red looks far warmer than green or blue. The key word is *comparison*. Develop your color sensitivity by comparing colors near each other on the color wheel.

Look at the three reds—red-orange, red and red-violet. In comparison, the red-violet is the coolest color. This same situation is obvious with the three blues—blue-violet is a little warmer than blue, and much warmer than blue-green.

Yellow seems like such a warm, sunny color, and it is if it's a yellow umbrella on green grass against a blue sky. Compare yellow to red-orange and it suddenly looks cooler. Compare yellow to violet and you may change your mind.

Pushing a Color

A color is like a sentence: You understand it best when you read the entire paragraph. You can't fully understand a color's impact unless you look at the colors surrounding it. When you contemplate your color charts and look around for similarities or differences, you may notice that some color interactions seem unusual. Have you ever noticed how gray eyes can appear to change color depending on the color of shirt their owner is wearing?

You can do the same thing with paint. I call it "pushing" a color. A large area of a color influences a small area of another color, making it appear brighter or duller. Sometimes you'll mix the most perfect color, but when you paint it you're surprised to find it just doesn't look right. Instead of struggling with larger and larger paint piles as you try for the perfect color, think! Take the time to analyze the color you are mixing and how the colors around it could be affecting your perception.

Colors Change Depending on Their Neighbors
The center of each of these squares is the same color: Cadmium Red Medium! Making a color look this different is done with both value and hue. In the orange square, the larger area of surrounding light orange makes the red appear darker (because the orange is lighter in value than the red) and cooler (a little bluish). Orange is a color with more yellow than red.

In the other square, the surrounding dark navy blue causes the red to appear both lighter (because the blue is darker in value than the red) and warmer (slightly yellowish). The blue has no yellow in it, so any yellow present in the red is accentuated.

Squint your eyes and look at these squares. Yes, the green inside each square really *is* the same color! The surrounding colors have "pushed" the green in two different directions.

In this example, see how your perception of the pink inside each square changes when the pink is surrounded by different colors. Experiment with various combinations of paint or colored papers.

Does this stuff *really* matter?

Working through the color exercises—not just reading about them—offers the solid foundation you need to ensure that the process of painting is more fun than frustration. Mixing color is the craft that the art of painting depends upon. Once you've completed your color wheel and the charts, you will have learned the basics you need to critically think about how to mix color.

Practicing your new skills will eventually enable you to mix color without even having to ponder the process. Even when you are not actually painting, you will see the colors in your surroundings differently. You'll find that your new knowledge will not only improve your painting, but it will influence the way you use color in your wardrobe, your home and your garden.

Look at the painting below and see how the different elements of color work together to form a painting. Later you'll learn more about how to use the colors you've mixed to evoke a mood and communicate your thoughts.

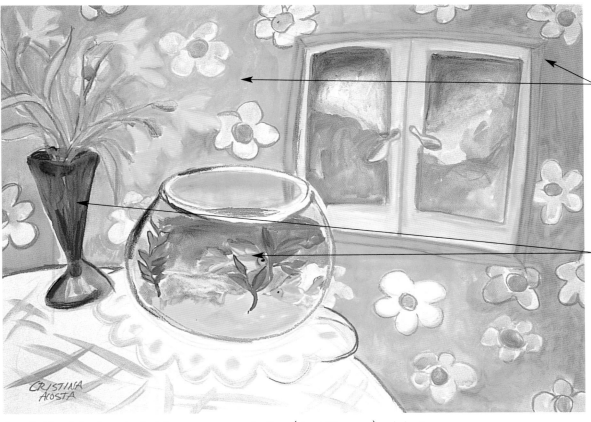

The part of the background that is a saturated deep orange contrasts with the tinted light orange in the middle of the painting.

Tints and saturated versions of hues are repeated in the coloring of the goldfish and the flower vase.

Overall, this painting is predominately warm oranges and yellows (about 70 percent) and about 30 percent cool blues, light blues and violet.

Goldfish and Daffodils • acrylic and pastel on 100-percent rag paper • 22" x 30" (56cm x 76cm) • photo by Gary Alvis

Let's Paint!

In this section you'll discover how to look at a painting and learn from it. When you paint you use (consciously or unconsciously) various concepts of design. As you progress through these chapters, you may notice some overlap. A painting is often composed using a variety of design concepts that interweave as you create your image. As you absorb each concept, you will become better able to learn from others' paintings and your own work.

The Music Festival • oil on canvas • 22" x 28" (56cm x 71cm) • collection of Stephen and Angelique Trono • photo by Gary Alvis

Variation and Repetition

Beautiful design is often a contrast between the variation and repetition of one or more design ideas. The design ideas you will work with in this chapter are line, shape, texture, pattern and edges.

The way you vary or repeat an idea is a balancing act of ratios. Use only repetition and the piece is very static. Use only variation and the piece may seem disorganized and difficult to make out. Make things evenly balanced and the piece may lack interest.

Play with altering the ratio of variation and repetition in your paintings. Most of the pieces in this book have a ratio of about 70 percent to 30 percent or even higher. Many pieces can be successful with ratios of 90 percent to 10 percent.

Follow along with the demos in this chapter and try out these ideas in your own work. Remember that these are guidelines, not hard-and-fast rules. After you thoroughly learn each lesson, you will probably find an example that breaks a guideline but still works. When that happens, think about why it works, and you'll have another design tool to use in your work.

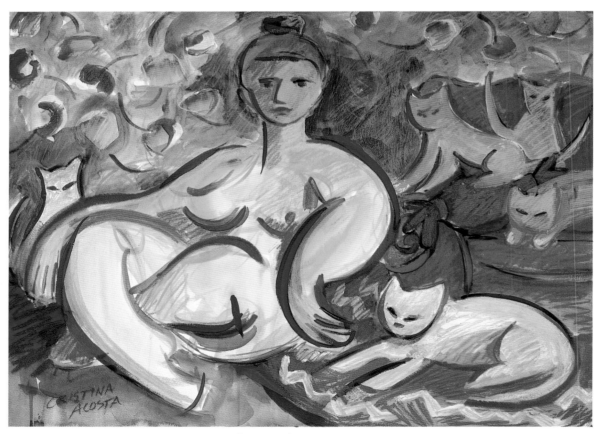

Goddess With Cats • acrylic and pastel on paper • 22" x 30" (56cm x 76cm) • collection of Janice Vick • photo by Gary Alvis

Straight *and* curved lines

Think of a painting as having one or more layers. The first layer is the base design layer. The second layer is the surface layer, where the basic design is elaborated upon. A third layer is present in a painting that portrays a deep space, such as miles of landscape.

The way you arrange shapes and lines in your painting guides the perceptions of the viewer and sets the emotional tone of your painting. Learn to see the directional movement of parts of a painting and you can more easily communicate your specific feelings to the viewer.

A good way to learn about the way an image is put together is to create a diagram. Remember diagramming sentences in English class? Well, you can also diagram a painting.

First, look for the shapes or lines (movements) that are the biggest and simplest; then see them as either curved or straight lines that are flowing in a particular direction. These lines could be the axis of the shape or a strong edge. Find the dominating curve, then look for some complementary straight lines. Look around the painting for a rhythm of curved versus straight lines. You will also see curved lines that counterbalance each other.

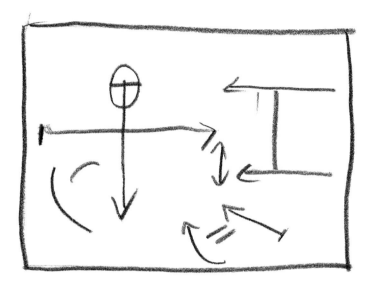

This is a diagram of the base design layer of *Goddess With Cats*, a two-layer painting. The dominant orientation of the major shapes and lines is horizontal and vertical. The basic design is about 70 percent straight lines and 30 percent curved. The curves, which tend to be a bit diagonal, are smaller and subordinate to the larger movement.

The overall posture of the female figure is a strong vertical (from her left wrist to the top of her head) with a strong horizontal (her outstretched arm). The smaller curves and diagonals of her body are within this larger stable design.

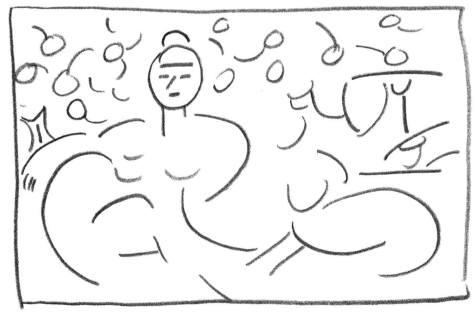

When the design is elaborated upon, the surface layer of this painting becomes about 85 percent curved lines and 15 percent straight lines. The large, simple lines and shapes are subdivided or broken up within the larger shapes. The color of the woman's body in the finished painting unifies the subdivided lines and shapes by restating the basic design of the image.

Tip

Lines have an implied sense of movement. *Vertical* lines are stable with the potential to change. *Horizontal* lines are very stable, resting and unmoving. *Diagonal* lines are either moving toward a stable vertical or falling to a resting horizontal.

Juggling clown

materials

Paper ✳ 18" x 14" (46cm x 36cm),
minimum 90-lb. (190gsm) weight

Brushes ✳ no. 4, 8 and 12 rounds ✳
no. 4 and 8 flats

Acrylic Paints ✳ Black ✳ Cadmium Red Medium
✳ Cadmium Yellow Medium ✳ Carbazole Violet ✳
Hansa Yellow Light ✳ Permanent Green ✳
Phthalo Blue (Green Shade) ✳ Phthalo Green
(Blue Shade) ✳ Pyrrol Orange ✳ Quinacridone
Pink ✳ Ultramarine Blue ✳ White

Pastels ✳ black ✳ blue ✳ green ✳ orange ✳
pink ✳ purple ✳ red ✳ white ✳ yellow

Other ✳ spray fixative

The subject of these images is a juggling clown. Look carefully at the following drawings. The base design layer tends to give the final drawings a similar sense of movement, regardless of whether the surface layer is primarily straight, mostly curved or balanced.

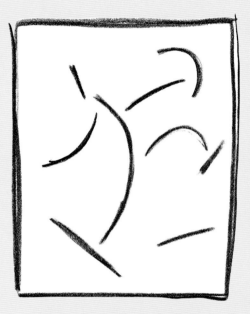

This diagram is the base design layer. The main curved axis line defines the core of the clown figure. The other lines define either a directional axis line of a shape or a strong edge of a shape.

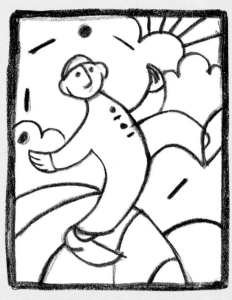

This image is composed of 90 percent curved lines and 10 percent straight lines.

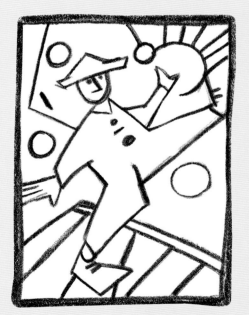

This drawing is the opposite, containing 90 percent straight lines and 10 percent curved lines.

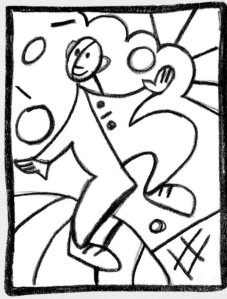

The balance of this drawing is about 70 percent curved lines and 30 percent straight lines. This is the drawing we will use for the painting.

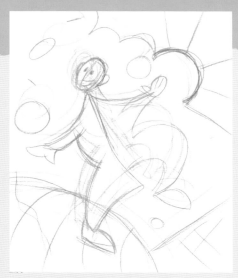

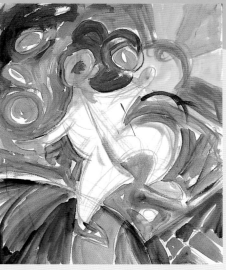

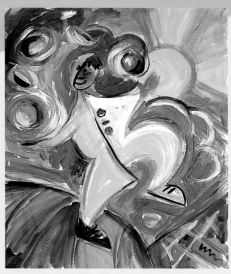

1| Make a Drawing

Roughly redraw the image with your pastels. Use yellow to begin with, then red when you feel your drawing seems right.

2| Begin Painting

Begin laying in color using your acrylics. The basic color arrangement is about 35 percent warm yellows, oranges and reds and 65 percent cool blues, violets and greens. Stay true to the ratio of curved and straight lines from the original drawing. Vary a line only if you seem to run up against it too many times.

3| Start Adding Pastels

Use your pastels and paints interchangeably as you build the image. If you need to make a color change, use paint to lay new groundwork. If the paint must go over some heavy pastel, spray the pastel with fixative to keep it from smearing into the paint.

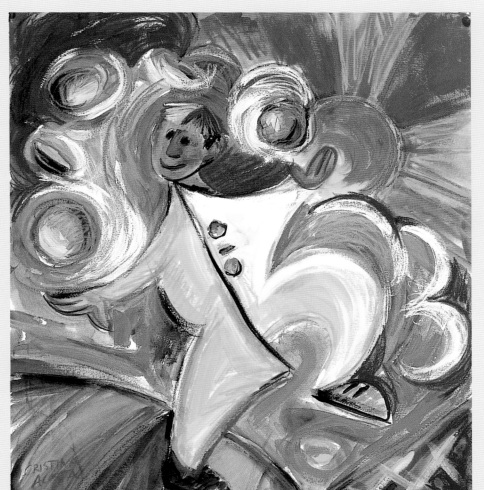

4| Finish

Finalize the image with pastel wherever you need it. The warm colors tend to be surrounded by the cool colors, except for the sun in the upper-right corner. This warm corner pulls the yellow center (the clown) up toward the sun. This emphasizes the upward motion of the clown, making his large body seem light and agile.

Try This!

Take one of your puzzle-piece drawings from chapter two.
Redraw your image with 90 percent curved lines, then do another with 90 percent straight lines.

Large *and* small shapes

Varying the size of shapes can have many different effects. Large shapes can appear to be closer to you than smaller shapes, and they may dominate smaller shapes. Put small and large shapes beside each other, and the space occupied by the shapes becomes flat, like an architect's drawing. Both shapes seem to occupy the same space and merge into one larger shape.

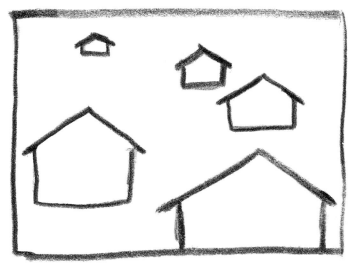

The largest house shapes seem to be the closest to you, and they appear to be floating in space. The background does not give you any information about where the houses are.

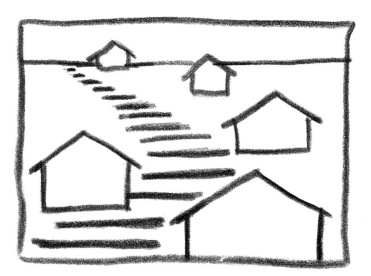

Add a horizon line, and the house shapes exist on ground. The parallel horizontal lines of the pathway become shorter and closer together as they curve toward the horizon line. This deepens the appearance of the space the shapes occupy.

Overlap a large shape with a small shape and you change the illusion. Now the smaller shape appears to be closer to you.

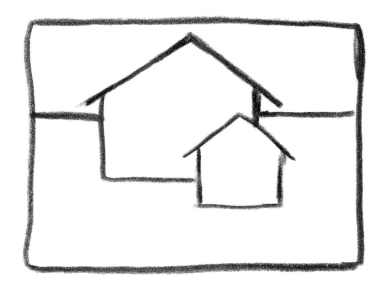

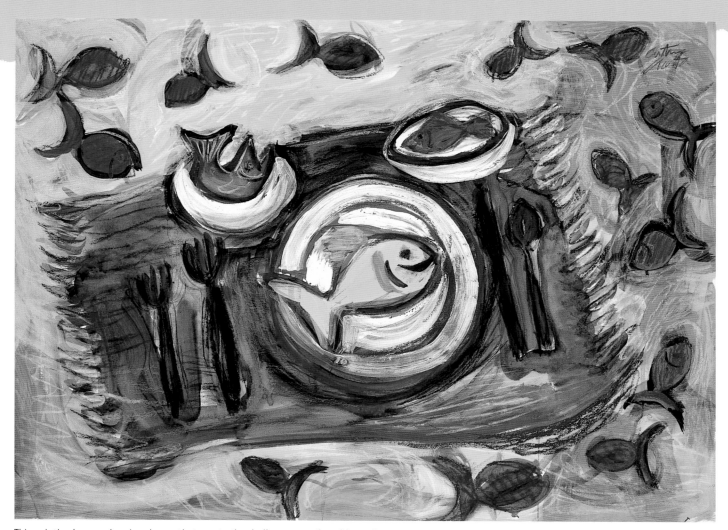

This painting has overlapping shapes that create the shallow space of a table setting.

Fish Dinner · acrylic and pastel on paper · 22" x 30" (56cm x 76cm) · photo by Gary Alvis

The basic shape design of this painting is simple and reminiscent of a nautical flag. The largest shape is the paper itself. The medium-sized shape is the placemat, and the smallest is the central plate.

This is the diagram of the surface design. The varied sizes and directional movement of the fish shapes energize the painting and create a sense of lively movement across the simple, basic shape design of the piece.

How a painting takes shape

materials

Paper ✳ 14" x 22" (36cm x 56cm), minimum 90-lb. (190gsm) weight

Brushes ✳ no. 4, 8 and 12 rounds ✳ no. 4, 8 and 12 flats

Acrylic Paints ✳ Cadmium Red Medium ✳ Cadmium Yellow Medium ✳ Carbazole Violet ✳ Hansa Yellow Light ✳ Permanent Green ✳ Phthalo Blue (Green Shade) ✳ Phthalo Green (Blue Shade) ✳ Pyrrol Orange ✳ Quinacridone Pink ✳ Ultramarine Blue ✳ White

Hard Pastels ✳ aqua ✳ blue ✳ green ✳ orange ✳ pink ✳ purple ✳ white ✳ yellow

Other ✳ spray fixative

Diagramming the basic idea of your image gives you a much higher possibility of success for your painting. You become aware of your design process at the beginning, working out the large concepts before you put a lot of effort into the small details. You'll see this in action for the following painting, *Forest Moon*.

These beginning sketches give you an idea of the design thought process. The "cabin in the woods" was the initial idea for this painting, but it lost out to the "birds in the forest" idea (the sketch with stars by it).

1| Make a Drawing

A light aqua pastel sets the right mood and is a light enough color to begin your drawing. Switch to a light pink pastel once you are more sure of your lines. The pink and aqua together are summery colors. I decided at this point to create an image of a summer forest with the moon setting in the early dawn.

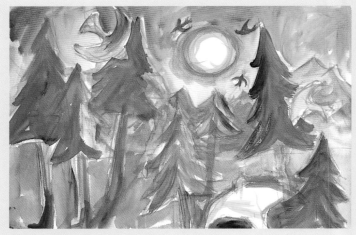

2| Start Laying In Acrylics

Begin laying in colors that appeal to you. I liked the aqua and pink in my initial sketch, so I decided to work primarily with pink and green. The sky became the pink of an early morning; the mountains became purple, which is analogous to pink. Making the pink and purple the same value allowed both colors to recede and create a background for the green forest.

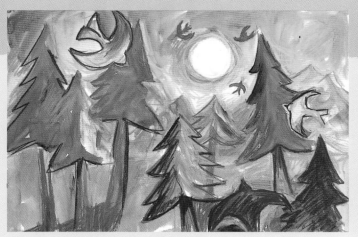

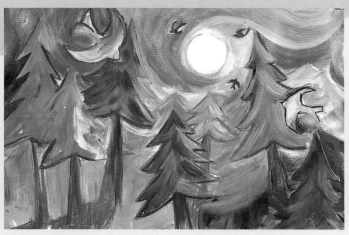

3| Introduce Pastels and More Paint

Use your paint and pastels interchangeably to begin defining the scene. I call this part "setting the color." Fill the paper completely with the colors for the image. This way you can see how the colors relate to each other and whether the image seems to work.

4| Analyze and Adjust

This part of the painting was a struggle. I had to stand back and analyze why I felt that the painting was becoming more difficult to complete. I realized my ratio of warm to cool colors was a little too equal. The yellow-green of the trees is the warmest area along with a touch of hot pink and the orange bird. The blues, bluish greens and the light pink and purple are the cool areas of the image.

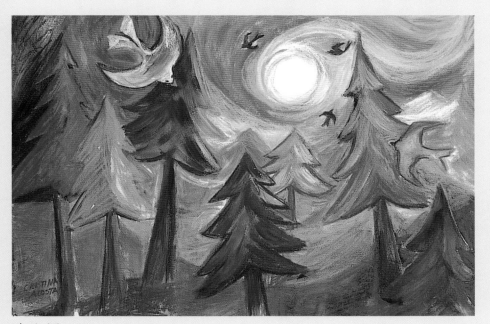

5| Finish

When I changed my ratio of cool to warm colors to about 75 percent:25 percent, the image flowed easily to completion. This painting emphasizes shapes. The simple tree shapes and birds change size and position to indicate the depth of a forest. I emphasized the contours of the ground to echo the contours of the sky. The only nonpointy shape in the painting is the round moon. It is also the lightest shape, creating a strong focal point for the painting.

Notice how using strong ratios can create a more interesting painting. Along with the cool-to-warm ratio, I used 90 percent pointy shapes to 10 percent rounded shapes and 80 percent bright colors to 20 percent light-valued colors.

Tip

Like life, a painting may not follow your plans. Often, the process of painting becomes a conversation between you and the painting, and that conversation may go in a different direction than you had intended. Stay flexible and be open to your intuition. You may finish with a painting that is far better than you could have imagined!

Smooth *and* textured surfaces

Texture can exist in three dimensions or as an illusion. The texture may be used as a surface embellishment or to create an illusion of space. Again, the balancing act of design comes into play.

Hatch *Stipple* *Crosshatch* *Scribble*

Create the illusion of texture by making marks with a pencil.

Use a dry brush to emphasize the texture of the paper.

Wet your brush with watery paint and the color of the paper comes through.

Load a moist brush with a generous dollop of paint and you have flowing control over the mark you make.

Try This!

Making these textures with a variety of brush types and sizes is great practice.

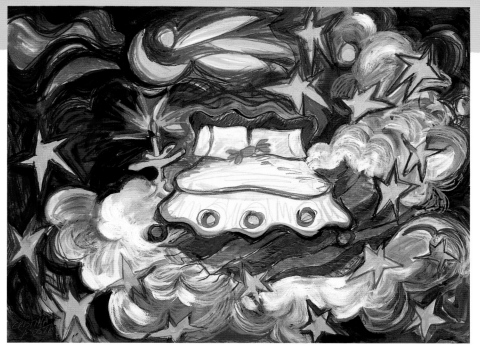

The painting *In the Fluffies* employs texture to create surface interest. The painting seems to be very flat in most areas and has a little depth in other passages. Overall, the use of texture to embellish the painting emphasizes its surface and keeps the image flat.

In the Fluffies · acrylic and pastel on paper · 22" x 30" (56cm x 76cm)

Compare these two pieces to see the difference in the use of texture. The presence of texture in *Star Juggler* creates the sense of a sky glittering with ice crystals and stars. Contrast the feeling of that winter sky with the sky in *Santa's Gift*. That smooth sky is crystal clear and cold. The three snowflakes hang almost motionless in the still sky.

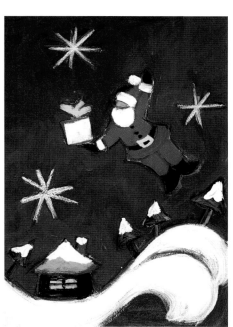

Santa's Gift · acrylic on paper · 14" x 11" (36cm x 28cm)
· photo by Gary Alvis

Star Juggler · acrylic and pastel on paper · 30" x 22" (76cm x 56cm) · photo by Gary Alvis

Patterned *and* plain surfaces

Patterns can enliven your painting. Patterns differ from texture in that they always emphasize the surface of the paper. Use a variety of patterns in contrast to plain areas. Think of them as an embellishment. Play with the art of balance. Push the patterns up to 90 percent of the image, then down to 10 percent of the image.

Try This!

These paintings use pattern in various ratios and values. Make a few copies of one of your puzzle-piece drawings and experiment drawing and painting different patterns on them.

About 70 percent of this image is patterned. Compare the strong linear patterns of *Yellow Bird and Bouquet* with the softer patterns in this piece.

Bahamian Catnap • acrylic and pastel on paper • 22" x 30" (56cm x 76cm) • photo by Gary Alvis

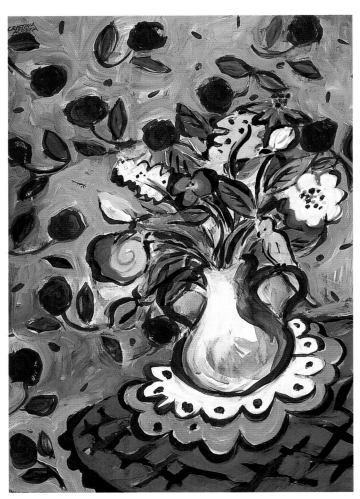

Strong patterns embellish about 70 percent of this image. The curving, circular blossomed floral wallpaper contrasts with the grid pattern of the table. The squiggle pattern is repeated three times, in the table edge and the two layers of doilies. The dots on the doilies echo patterns in the floral arrangement and the circular shapes on the wallpaper.

Yellow Bird and Bouquet • acrylic on paper • 30" x 22" (76cm x 56cm) • photo by Gary Alvis

Patterning 90 percent of the image emphasizes the whimsy of this painting. The variety of pattern encourages your eye to travel easily around the drawing. Darker-colored pastels are used to emphasize the pattern in an area. Patterns drawn closer in value to the painting underneath tend to be subordinate to areas of higher contrast.

Cat on a Cushion · acrylic and pastel on paper · 18" x 15" (46cm x 38cm)

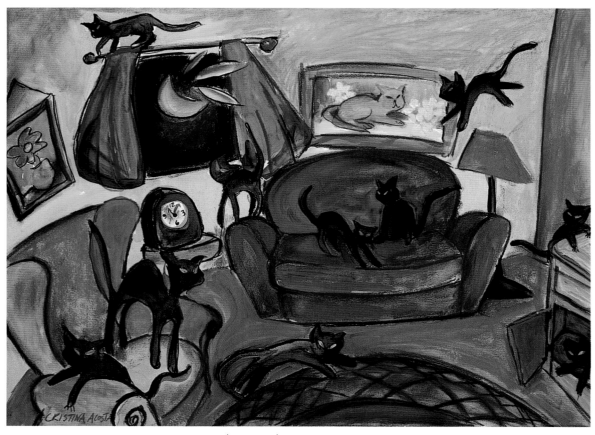

This piece is only about 10 percent patterned (the rug and both framed pictures on the walls). If you used too much pattern in this image, the various dark shapes of the cats would be difficult to see.

Millions of Cats · acrylic and pastel on paper · 22" x 30" (56cm x 76cm) · photo by Gary Alvis

Soft *and* hard edges

Sometimes artists call these "lost and found" edges. A subtle, blended mark creates a soft (or *lost*) edge on an object. A strongly made mark creates a hard (or *found*) edge.

In the examples on the next page, edges ease a passage between colors or create strong lines. Put different colors of similar value next to each other and you create a soft-edge area that is interesting but keeps the eye moving.

Hard edges create strong lines of movement. There is quite a rhythm of hard and soft edges in these drawings and paintings.

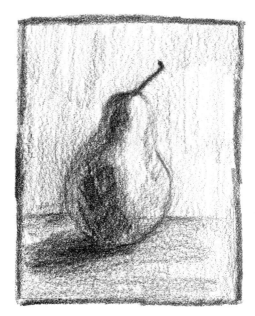

This pear has about 90 percent soft edges and 10 percent hard edges. Notice how your eyes quickly seek the hard edges to discern the form. This is exactly the same sensation as seeing something come out of the fog. Your eyes seek enough edges to identify the form.

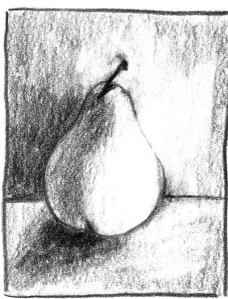

In this pear drawing, about 90 percent of the edges are hard. The mood of this piece is very different from that of the first pear drawing. Strongly delineating the shape of the pear requires fewer assumptions from the viewer; therefore, you create less mystery.

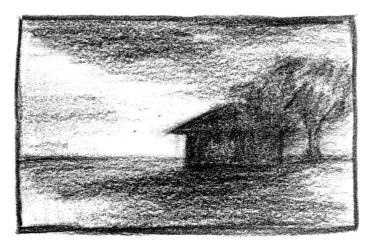

This landscape sketch with 90 percent soft edges evokes a sense of mystery.

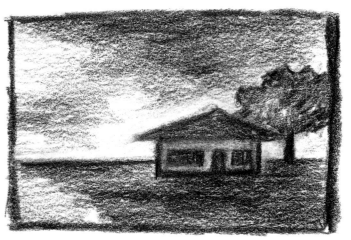

Create more hard edges, and the landscape seems straightforward.

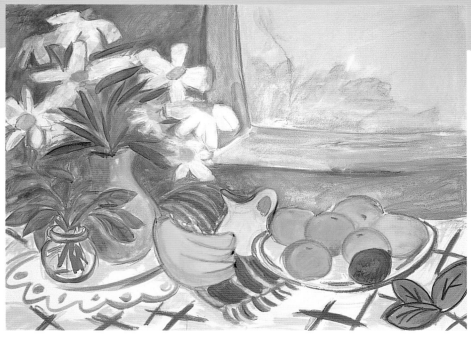

Hard edges are in the foreground of this painting. The soft edges of the flower petals and from the wall to the yellow window create a sense of atmosphere.

By the Kitchen Window · pastel on paper · 22" x 30" (56cm x 76cm) · photo by Gary Alvis

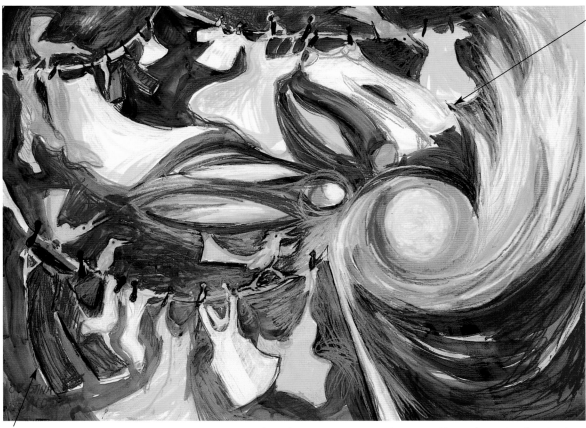

The soft edges of the white pants and blurred hem of the yellow dress blend with the wind vortex created by the sun. This contrasts with the hard edges of the sun against the blue sky. The alternating pattern of hard and soft edges heightens the sense of wind movement.

Your eye moves through this area quickly because these colors are the same value. This creates a soft edge that makes the shape of the pants blend with the ground.

Laundry on the Line · acrylic and pastel on paper · 22" x 30" (56cm x 76cm) · photo by Gary Alvis

Rhythm and Movement

E verything in a painting relates to visual rhythm and movement. The sizes and types of shapes, brushstrokes, lines, colors and textures create a language of meaning. Think of these elements as living beings—jumping, pushing, spreading, tightening, spinning, standing still and falling. What you let these elements do forms a painting's personality.

In this chapter you will learn how to recognize rhythm and movement and how to create it in your paintings. Begin by looking carefully at a painting. Every painting has a personality. Look at a painting and imagine it's a person you've just met. Describe to yourself the personality the painting has. Make up the painting's life story, and you'll find yourself learning a lot from any work of art you take the time to know.

Swing Dance • acrylic and pastel on paper • 22" x 30" (56cm x 76cm) • collection of Jeanne and Gary Giersdorf • photo by Gary Alvis

Diagram your discoveries

You can create rhythm and movement in a painting a variety of ways. You learned some of these ways when you worked with straight and curved lines and other various patterns, sizes and textures. Besides the skills you developed in the last chapter, there are a few other ways to study an image. Diagram paintings to learn how they are put together. Draw quick sketches of the design elements to help you see the paintings more clearly.

Follow my diagramming for *Seaside Seating*. Determine the sense of energy you feel from the painting. Ask yourself how it is conveyed. Apply these ideas when you look at other paintings.

Seaside Seating · acrylic and pastel on paper · 22" x 30" (56cm x 76cm) · photo by Gary Alvis

Start with what you know. Do an analysis of this piece using straight and curved lines.

Now look at the shapes. Notice how the sizes range from small to large.

Study the value arrangement. The pattern of darks and lights creates a rhythm of its own.

The relative warmth and coolness of the colors forms a pattern. The warm-colored areas are anchored to the sides of the painting and accent the majority cool colors.

Paint from real life to your life

materials

Paper ✳ 22" x 30" (56cm x 76cm), minimum 90-lb. (190gsm) weight

Brushes ✳ no. 4 and 12 rounds ✳ no. 4 and 8 flats

Acrylic Paints ✳ full palette

Hard Pastels ✳ full set

Nobody anywhere sees the world like you do. Whatever you see every day goes into your subconscious and builds a picture for you—a world view that is uniquely yours. In this book, you don't work from life exactly as it looks, but as you see and experience it. You are always developing your inner eye. With continued painting, your ability to creatively visualize will grow, and you will surprise yourself with the images you'll be able to create.

One way to begin painting with your inner eye is to start with a recent memory. This could be an incident, an experience or maybe just a glimpse of something that has stayed with you. Hold that thought and begin painting. Your image has a certain sense of movement. Using a light-colored pastel, begin drawing the curved and straight lines and shapes that the thought evokes. *The Garden Store* will show you the way an image moved from being a thought to becoming a painting.

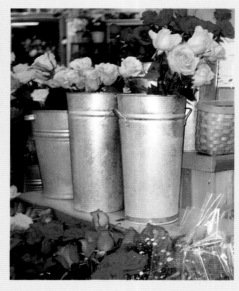

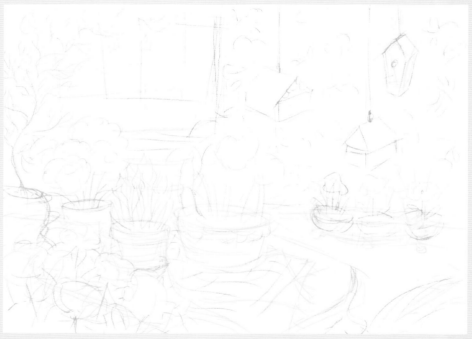

1| Make a Drawing

I began the painting by looking at my photographs and taking some time to relive the sensations of the memory. I taped the photos to my easel so I could look at them as I worked—not to copy the photos, but to remind me of the experience.

I began the drawing with a very light yellow pastel. I started with the birdhouses and a basket of flowers, then kept adding straight and curved lines until a scene appeared. I quit looking at the photographs and just let my hand move over the paper, thinking about what I experienced—not just that particular day, but also in any other memory of a nursery or garden store that happened to drift through my mind. I used my inner eye to activate my other senses and to completely "be there." The image seemed to draw itself. I redrew what I liked in a darker gold pastel.

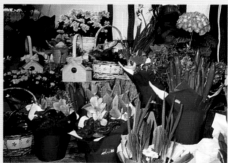

My neighborhood grocery store has a corner devoted to a beautiful garden and floral display. The air is filled with the scent of vibrant flowers and fresh produce. This market is always beautifully merchandised and bustling with activity. These photos give you an idea of what I saw.

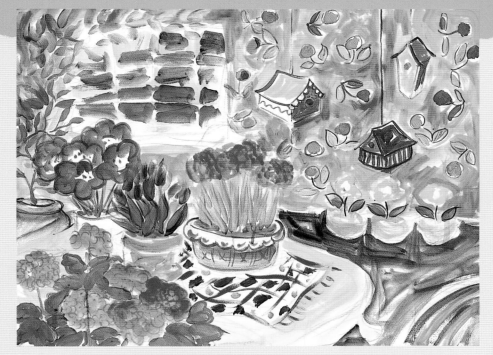

2| Begin Painting

The first brushstrokes were drawn lines of Cadmium Red using a no. 12 round. I then continued to set up all of the colors in the painting using only a no. 12 round and a no. 8 flat. I determined early in my painting that I would make it predominately warm colors (at least 70 percent) to emphasize the cool tones of the plant life. With that idea in mind, I quickly filled the back wall area with Quinacridone Gold and changed colors as the urge occurred. I painted the table a warm yellow and made the floor a warm purple. The blues and greens are cool accents, with the purple acting as a transitional color. Sometimes purple is a cool color (near the orange wall); other times it is a warm color (near the yellow table).

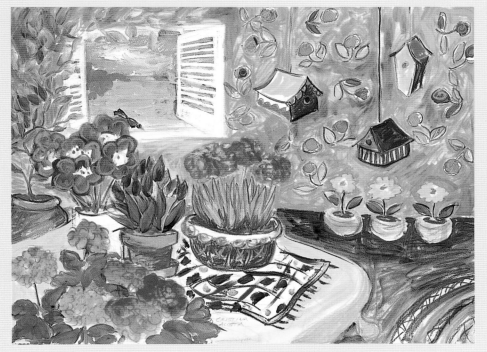

3| Finish Details and Make Corrections

I finished the painting with a final layer of pastels. I used gold and a range of yellow pastels on the back wall. A final layer of blue pastel over the purple floor was also used over the carpet and plants.

Often I'll use my pastels to define an area, and, at the same time, to add a small accent of color. The flowerpots on the floor and the stems of the flowers and tablecloth all have little bits of other colors added to develop their forms.

Compare the image to the photos. The grocery store floral department inspired me, then my imagination ran with the inspiration. The painting is consistent with the initial drawing, except for the window. I thought the windowpane was too choppy, so I replaced it with a shuttered window and added two birds.

Tip

Photographs can be a substitute for your memory or they can stimulate it (or both!). When you look at photographs, imagine yourself there. Imagine what your body feels like and the odors and sounds you encounter. Visualize yourself moving about the photo. Experience the photo fully, and your painting will be richer.

If you can't see it, imagine it!

How you perceive what you see is colored by who you are. Your experiences, the time and place you live in—these things are inescapable. There really is no such thing as objective art. Everything is subjective. Look at old photographs and you always sense the age and what the photographer was interested in, even if the image doesn't have anything "dated" about it.

The following paintings are all images that are physically impossible. Your imagination can go anywhere and do anything. Begin with a feeling. The feeling you want to convey determines the movement of the piece. The appearance of something may have caught my attention, but I begin with the feeling it evokes in me. To imagine an image, I continually hold the feeling with me as I work, and I rely on my subconscious to guide the creation of the image.

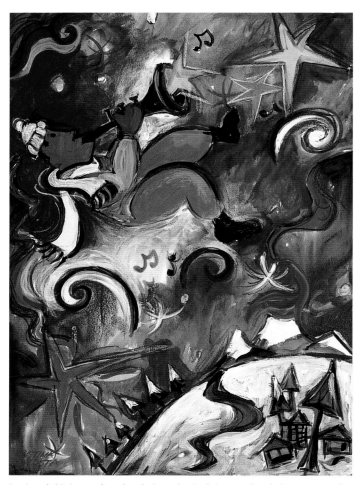

This painting is from a children's book. This creation story is set in pre-Colombian Central America, in what is now Costa Rica. This illustration was intended to introduce the character of Thunder and also to convey the text in the title. Sibu (the creator) was calling for Thunder as he danced across the tropical sky. I imagined that Thunder was formed out of lightning and had the look of a Mayan or Aztec warrior, with the personality of a loving clown.

The strong, swirling strokes of paint reinforce the flow of the air and the sense of high energy in the scene. The cool blues and violets surround and accentuate the warm colors of the two characters. Thunder has warm yellow and orange parts, and Sibu is a warm, earthy brown. The staccato-like black dashes suggest rain and energize the surface of the painting. The sharp points of Thunder's body and the jagged orange shapes around him suggest the feeling of static electricity—prickly and sharp.

"Sibu called for his friend Thunder as he danced across the sky…" • acrylic on paper • 17" x 25" (43cm x 64cm) • From *When Woman Became the Sea*, written by Susan Strauss, illustrated by Cristina Acosta. Hillsboro, Oregon: Beyond Words Publishing, 1998.

I painted this image for a local winter festival. I wanted to define a sense of place (the smallish town of Bend, Oregon, at the foot of the Cascade Mountains); a sense of time (midwinter); and a sense of the fun and activities at the festival. I thought of a man in warm winter clothes floating in a starry night sky as he plays his music over the snow-covered town. His rounded backside and the round horizon of the earth below create a tension in the blue sky space between the two curves. This tension enhances the sense of floating.

Winterfest Image • acrylic and pastel on paper • 30" x 22" (76cm x 56cm) • photo by Gary Alvis

Believe it or not, this painting wasn't created entirely from imagination. It was inspired by an old memory of my first night alone in an old ranch house. During the dark early morning hours I heard loud animal noises inside the house. There were no lights, so I decided to keep my head under the covers and wait until the animals left. Once the early morning sun began to light the room, I peeked out from under the covers and saw a clucking chicken standing on the foot of my bed! A tall rooster with a colorful tail was perched on the dining room chair by the picture window, and about six chickens were scratching the wooden floor and kitchen countertops. Apparently, there was a hole in the outside wall under the kitchen sink, and the chickens came in looking for breakfast!

More than a decade later, I took the best part of that memory—the comical surprise ending to my dark fear fantasies—and turned it into this painting. The rooster is crowing a rainbow of sounds toward the rising sun. My bed is the center of this universe and the land over which the sun rises and the clouds billow. This image captures a happy lesson about fear and worry.

Rise and Shine • acrylic and pastel on paper • 22" x 30" (56cm x 76cm) • photo by Gary Alvis

More than one way *to* paint *a* picture

Sometimes when you are painting, you may have a sense that the painting could go in more than one direction. The choices you must make may seem overwhelming. Which color is best? Should the window be on the right or the left?

The best fail-safe solution is to have two paintings happening at the same time, or paint one right after the other. Pretty soon you'll find yourself concentrating on one of the paintings. You may also find that the paintings diverge so much you end with very different versions of the same idea!

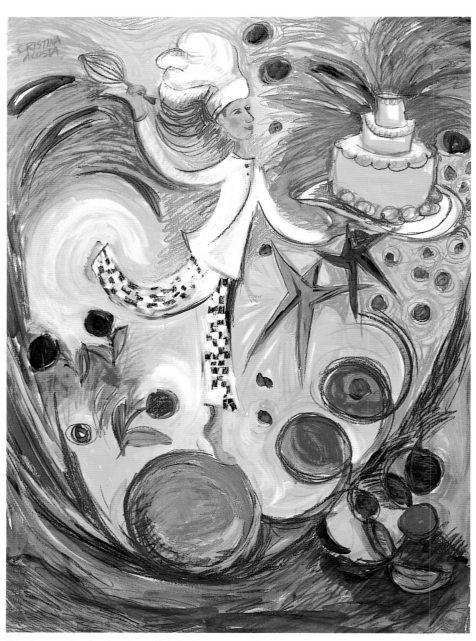

This piece was inspired by a beautiful slender woman walking barefoot across a polo field and carrying a large tiered cake with sparklers on the top. She had made the cake as a gift for a friend's birthday celebration, which happened to be on the Fourth of July. It was a magical image, and I could hardly wait to get home and paint. The bright, strong colors were a direct result of that evening's fireworks. The rolling ball the chef balances upon implies movement and reflects her vivacious personality.

Pastry Chef · acrylic and pastel on paper · 30" x 22" (76cm x 56cm) · photo by Gary Alvis

I liked the idea of working with the celebratory food theme. This piece was a study done after *Pastry Chef*. My goal was to try the theme without the chef, but I missed her too much, so I went on to paint *Celebration Chef*.

Treble Clef Saute Pan • acrylic and pastel on paper • 15" x 11" (38cm x 28cm) • photo by Gary Alvis

This piece was a divergence from *Pastry Chef*. I kept the composition the same but changed the emphasis from dessert to a full-course meal (including mood music!). The colors are softer, which makes the overall image a tad quieter than *Pastry Chef*.

Celebration Chef • acrylic and pastel on paper • 30" x 22" (76cm x 56cm) • photo by Gary Alvis

A series of possibilities can make a series

Sometimes you'll paint a picture that is so much fun you can hardly wait to repeat the experience. When this happens, go for it! Paint a series of images. The best thing you can do is to get it out of your system and onto your paper. When you work within a series, you will find that each painting contributes to the rhythm of the series.

There is no limit to the ideas you may think of that can become the common thread that unites several paintings into a series. A series can start with a single word: *angels, trees, home, family, dance* and *play,* for instance. You may find that a sentence from a poem or a line from a song fills you with visions. Look and listen to the world around you, and let it inspire you.

This series of place settings is energetic and fun. The colors are as bright and happy as a summer fruit stand. Some of the color schemes are predominately warm, and others have cool color schemes. Each piece differs in its inspiration and has a sense of energy specific to its subject matter. Some of the settings were inspired mostly by a memory, others by imagination. View them together and you sense the life energy in a meal.

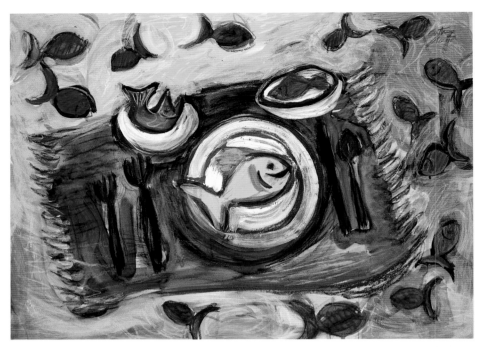

Remember this painting from chapter four? It was so much fun to create that I couldn't stop until I'd painted four more. Would a fish on a dish have a smile on its face? Well, probably not—but this is my world, so it does!

Fish Dinner • acrylic and pastel on paper • 22" x 30" (56cm x 76cm) • photo by Gary Alvis

Try This!

Create a series beginning with one of your favorite images. Explore aspects of that subject matter. Think of your series of paintings as a group of siblings that have a strong family resemblance yet are all different.

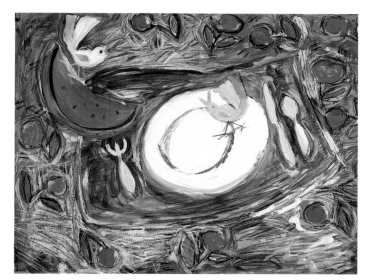

Picnic was my second piece in the series. When I was a child, my mother would often let our parakeet out of its cage to fly around the house. He'd perch almost anywhere. I painted a watermelon because I love the color red, and watermelons are a summer fruit that reminds me of picnics. The blues, violets and greens that dominate the color scheme are shady, cool colors that balance the hot reds and yellows of summer flowers, fruits and birds.

Sunnyside Up is a continuation of the memories that inspired the painting *Rise and Shine* (see page 61). When I lived on an old homestead in Oregon, I was surprised to find that chickens got into the house one morning, looking for breakfast. The chickens on my tabletop and countertops was an image that never left me. The checkerboard pattern on the right and bottom of the piece suggests a country tablecloth. The green placemat is sort of a grassy meadow with the sun coming up. Sunny yellows dominate the color scheme, reinforcing the idea of a sun-drenched early morning.

I love eating hot peppers and Mexican food. If you've ever eaten too many peppers, you can relate to *Southwest Supper*. Your head feels electrified, and you burn up! Rather than just paint a piece with chili peppers on it, I conveyed the experience of eating spicy food by using desert images that define the topography of the Southwest. A sweltering red sun burns across yellow desert sand; coyotes and wildcats leap and howl; a sparse cloud that yields more lightning than water hovers over the place setting. The rare cool green of a prickly pear cactus, which is used in Southwest cuisine, and the limited use of cool colors reinforces the sense of the scarcity of water.

In *Midnight Supper* even the red seems cool, bluish and dark. The plate is a moon-colored circle covered with a dessertlike presentation of stars. The dark blue night surrounds the place setting. The observant owl seems to naturally sit on the fringe of the placemat (parakeets and chickens are asleep by now!).

This piece has less activity than the others and seemed a fitting end to the series. I didn't know it at the time, but I ran out of ideas and excitement after this; I'd covered all of my favorite meals! I may revisit this idea in the future—it was a lot of fun.

Shapes and Sizes

W hen you made your first puzzle-piece drawing in chapter two, you began working with shapes and sizes. You learned that the object and the background are both shapes. Every part of your paper or canvas, whether you paint on it or not, is part of a shape. In this chapter you'll study in depth the variation and repetition of shapes and sizes.

In many pieces of artwork, you see a repetition of a shape or part of it. That shape often varies in size and may be slightly altered, but it is still recognizable as the original shape. You may also see a variety of sizes of certain types of shapes—angular, rounded and organic. Notice the variation and repetition of the types, sizes and colors of shapes in a painting.

Sometimes an image you have in mind seems to go perfectly with a certain type of shape. Your subject matter may suggest a sense of roundness or angularity. If you have a strong sense for this, construct your painting with a dominant shape and see where it takes you.

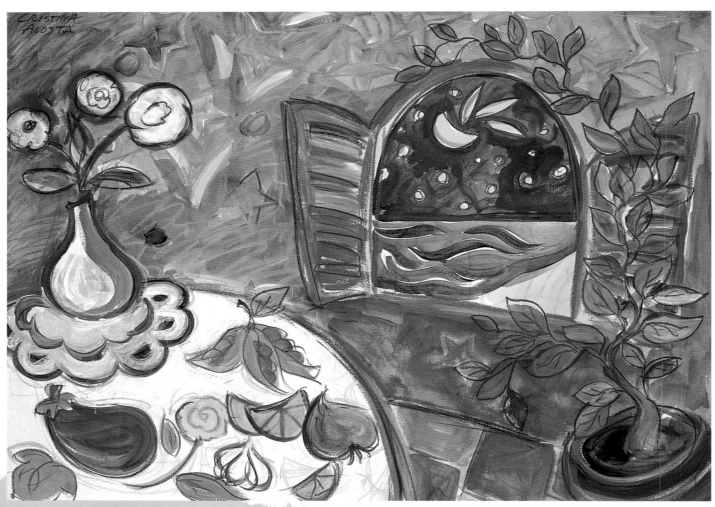

Moonlight Seaside Supper • *acrylic and pastel on paper* • *22" x 30" (56cm x 76cm)* • *photo by Gary Alvis*

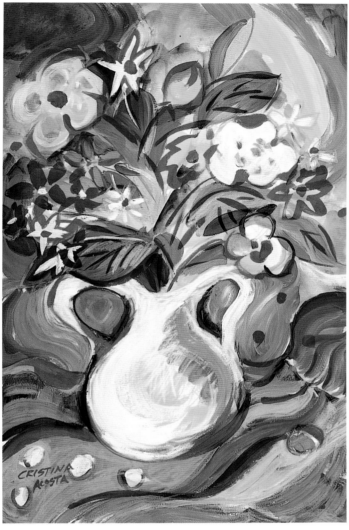

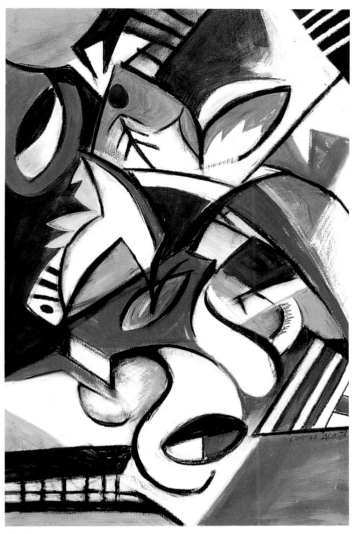

Original Painting

During the process of reinterpreting this painting, the elements I decided to work with are the stripes of the table and background and the rhythm of leaves and flowers in the bouquet. The calligraphic red lines transformed into strong shapes.

Garden Vase • acrylic and pastel on paper • 25" x 17" (64cm x 43cm) • photo by Gary Alvis

New Interpretation

For inspiration, I looked at paintings created by Pablo Picasso between 1918 and 1924. With those images in mind, I set my painting *Garden Vase* in front of me along with a page of Picasso's paintings, and I reinterpreted the image as I imagined Picasso would have painted it. The color scheme changed to one Picasso might have used, but it is related to my original image. The painting changed from a loosely painted image of implied shapes and forms to an image of definite shapes and a number of spatial plane changes. Can you see the connection between my two paintings?

Vase #1 • acrylic and pastel on paper • 24" x 16" (61cm x 41cm)

⭐ *Tip*

Let history be your teacher. When you look through art history books and find a painter whose style particularly appeals to you, re-paint a few of your own paintings as though you were that painter. Working in another's style with your own ideas is a great way to learn about painting.

Does size matter?

Of course it does! Varying the sizes of shapes can make your painting appear more interesting. When you change the size of a shape, it's very important to consider where you are placing that shape. We "read" shapes in a certain way. Smaller shapes tend to recede, and larger shapes remain in the foreground. This isn't always so—overlap a large shape with a small shape and then the small shape comes forward. Keep the shape, change its size and move it to a different part of the paper, and you've just created distance. Change the color of the shapes and you can enhance the illusion of distance.

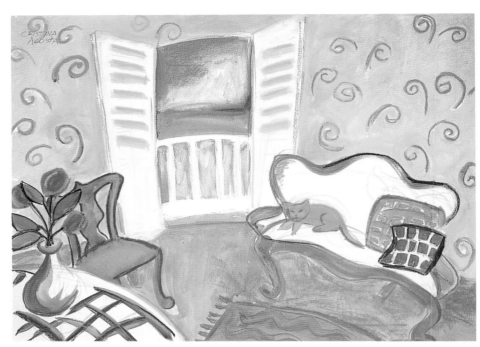

The shapes in this piece reference each other and create distance by overlapping each other. The whites of the chair, door shutters and porch railings are the same. The divan overlaps the shutters, pushing the doorway back. The white on the pillows is part of the square shape that overlaps the divan. The grid shapes repeat across the pillows and tablecloth. Thin rectangles in the shutters, railing and fringe of the rug are variations of the same shape.

Bahamian Catnap · acrylic and pastel on canvas · 22" x 30" (56cm x 76cm) · photo by Gary Alvis

This image was created with very strong shapes. The circles are repeated over almost the entire piece; they change size from large polka dots to small dots on the dog and even smaller dots as musical notes. The circles repeat again as loopy squiggles. Look for other shapes or fragments that repeat throughout the painting. The black outlines reinforces the two-dimensionality of the painting.

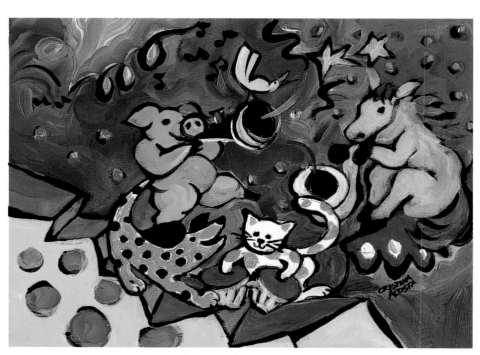

Party Animals · acrylic on canvas · 11" x 14" (28cm x 36cm) · photo by Gary Alvis

When more *is* better

Knowing when to stop and when to keep working is always a decision of experience and personal taste. Always strive to work from your unique sense of vision. An easy-to-understand example of a unique viewpoint is found in home furnishings. The lines of a Shaker chair are very different than those of a chair carved to look like a roaring dragon, yet both are very beautiful and admired by collectors.

Play with over-the-top painting in your work. Embellish a painting with extra shapes in a variety of sizes and colors. Push yourself to challenge what you think is your taste. You may surprise yourself with what you create.

Strong color, value contrasts and brilliant shiny metals are anchored by a strong, swirling composition. The repeating shapes of flowers and stars are intentional patterns that float over the curtain of night— or is it the dreamer's hair? The space in this painting ranges from surface floral and star patterns to an implied deep-indigo starry night. The variety of design elements in this painting evokes aspects of dreaming—overlapping visions that may or may not form meaningful patterns. For me, a more simplistic version of this subject matter would not have conveyed the mystery implicit to dreaming.

The Dreamer and Her Angel · acrylic and pastel with sterling silver and composite metal leaf on paper · 22" x 30" (56cm x 76cm) · photo by Gary Alvis

When enough *is* enough

Here we are at the other side of knowing when more is better. You may be in perfect flow with your work and have no doubts that you are finished. Other times, deciding to stop is simply a matter of running out of anything else to do. This applies both to parts of your painting and to the whole.

All of the shapes that you create fit together to form the whole. Even if the whole or part is only partially present, your mind will fill in the rest. Think about connect-the-dots coloring books. Often, if you look at the dots long enough, you'll be able to see the image without any connecting lines. Your mind continually takes bits and pieces of things and fills in to create known forms or shapes.

Sometimes what we think we see is really based on an assumption our mind has put together. Be aware of this principle and use it to your advantage in your work. You won't have to work quite so hard to get your vision across!

Sometimes I go too far over the top with a painting, and then I have to uncomplicate the image. I had a hard time getting started with the painting *Late Night Dessert* and struggled with it most of the way. Halfway through the painting, I found it to be in desperate need of simplification.

Original Sketch
I had a hard time finding an idea, so I just kept making light yellow marks until I saw something. The idea I settled on was to paint a late-afternoon picnic dessert. When the placemat and plate appeared, I drew the final image with a light violet pastel (it seemed like an afternoon sort of color).

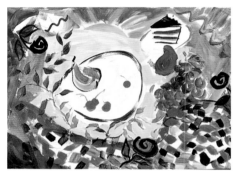

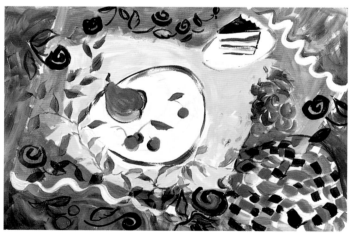

First Attempts
When I began painting, I decided to make the image very red and pink. At first the painting went smoothly, then I started to struggle with the image. I just couldn't seem to get the checkered tablecloth to work. Remember in chapter four how I encouraged you to use a planning process? Well, I just couldn't seem to come up with a plan that stuck. I really loved my checkered tablecloth and held onto it in smaller and smaller areas.

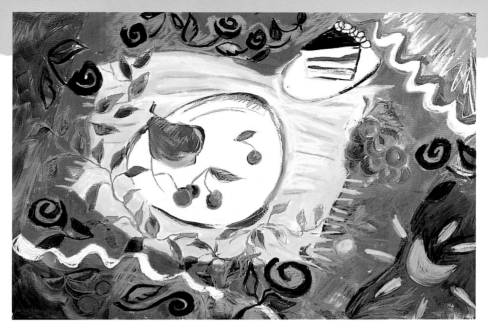

Uncomplicating the Painting
I finally got tough with myself and got rid of the entire tablecloth. My attachment to one part of the image was holding back the entire image. As soon as the tablecloth was gone, the rest of the image practically painted itself.

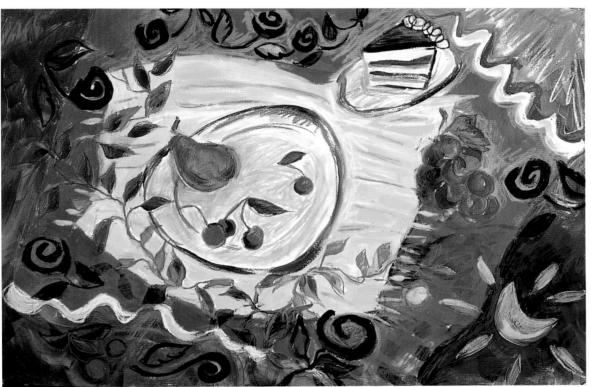

Finished Painting
I did most of the final work with hard pastel. I really enjoyed playing with the degree of finish on this piece. Look at various parts of the painting. The grapes and pear are painted more realistically than most anything else, yet the method is suggestive rather than specific. Their form is emphasized in contrast to the flat shapes surrounding them. The vine is a unifying element that is painted flat and patternlike in some areas and realistically in others. The entire plate and background seem flat and patternlike until, in the lower right corner, you are suddenly thrust into a night sky with a glowing moon.

Bits and pieces of the painting underneath show through in places. Because I did not overwork these areas by trying to perfect them, the painting retains the spontaneous mood in which it was conceived.

Late Night Dessert • acrylic and pastel on paper • 17" x 25" (43cm x 64cm)

Tip
If you find yourself constantly dabbling on a piece, your nit-picking may have more to do with your lack of faith in yourself, rather than a lack of "finish" of the image. Sometimes simplicity is elegance; sometimes complexity is elegance. Remain open to your intuition, and stop when the painting demands it.

Geometric *and* organic shapes

When you draw a shape and link it with others, you may notice that, overall, the shapes in your painting are either *geometric* (distinct circles, squares, triangles) or *organic* (free-form shapes such as clouds, flowing water, a grouping of trees). Organic shapes at their basic levels are geometric, but, for now, ignore the finer points of mathematics and think of shapes as either geometric or organic.

You may find that your subject matter evokes either a strong feeling of angularity or a flowing, organic feel. You may want to use certain shapes to suggest a particular feeling. Understanding how the mood of an image changes because of the types of shapes you use gives you one more tool to use to effectively convey your feelings.

In these two paintings, determine which type of shapes dominate the image. You may find yourself using a particular type of shape more often. If you find yourself always painting the same types of shapes, take a break and try the opposite variety.

Flowing organic shapes dominate this image and convey the sense of flow I feel when I am truly inspired as I paint. The strong geometric circles make up 15 to 20 percent of the painting. The largest circle is the woman's arm embracing the angel. The circle is repeated as the oval of her face and the bloom of the flower the angel offers her. The central geometric circles form the underpinning for the swirling organic shapes that form the dominant remainder of the composition.

The Angel Whispers · acrylic and pastel with metal leaf on paper · 30" x 22" (76cm x 56cm) · photo by Gary Alvis

In this painting, strong geometric shapes act as a frame that focuses the center of interest on the organic shapes of the frog. This piece is about 70 percent geometric shapes (the leaves and dragonfly) and 30 percent organic shapes (the frog and the swirls in the background). To create paintings with movement, always balance your design elements at an uneven ratio. I often work with all the design elements in ratios of 70 percent to 30 percent or higher.

Rainforest Frog · acrylic on painting board · 10" x 14" (25cm x 36cm) · photo by Gary Alvis

How does *a* shape take on form?

Transforming a shape into a form always seems like a bit of magic, especially because you are creating an illusion of a three-dimensional world on a two-dimensional surface: your paper. Simply, a *shape* is two-dimensional and a *form* is three-dimensional. Shapes tend to read as flat areas of your image that reaffirm the two-dimensionality of your paper. Forms tend to read as being three-dimensional objects.

The decision of when to emphasize shape or form is different with every image and for every artist. Generally, you'll find that when you emphasize color, flat shapes dominate your painting. When you emphasize value, three-dimensional forms dominate.

As your awareness of shape and form grows, you will be able to see the shapes you create as you paint. Study the examples on the next few pages to learn how to simply create forms from shapes using line, color and value. Acquire this crucial skill and you will find that painting and drawing images comes much more easily.

Creating Form With Line

Did you ever doodle squares and then, by repeating the doodle and connecting the lines, make a cube? Practicing this exercise will help enhance your ability to create forms.

When you create form with line, you divide a large shape into smaller segments that still remain within the larger shape and help your eye see a three-dimensional form. Your mind reads the smaller segments together as a whole form.

Practice doodling cubes using a pencil, pen or paint.

Using Line to Make Shapes Into Forms

Start with an outline of a shape.

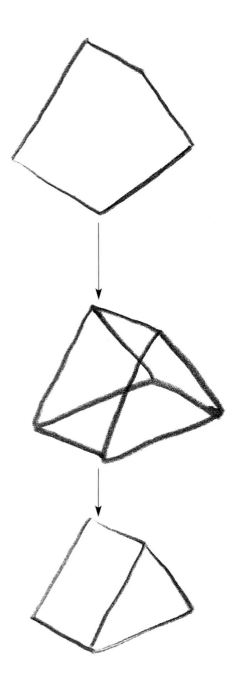

Add lines to help you see the form's entire structure.

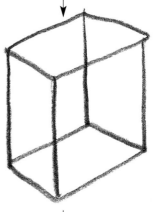

Erase the lines that you cannot see through the solid form.

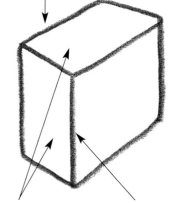

Each side of a form is a plane.

This area is the transition—the spot where planes meet. The transition between angular planes is abrupt.

The transitions between the planes of a cylinder are subtle.

Creating Form Using Values

You can also create form by using values. Three values are almost always enough to convincingly create the illusion of a solid, three-dimensional form.

When you create a form, determine where the three dominant values are. Identify the middle value and then the darkest and lightest values. Don't include the highlight or a dark accent area. Picture the dominant three values of a form as the cake and the highlights and dark accent areas as the frosting.

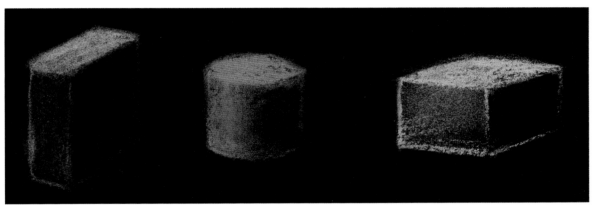

Use hard pastels on black paper for this exercise. Start with a line drawing of the shape, then thickly color the plane getting the brightest light. Smear the color over the rest of the shape. Use your eraser to rub out the darkest plane, and more pastel to enhance the brightest plane. Vary the transitions between the planes from soft to hard.

Cadmium Yellow Medium

Quinacridone Pink with a touch of white

Cadmium Yellow Medium

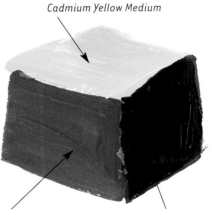

Permanent Green *Phthalo Green*

Cadmium Red Medium *Anthraquinoid Red*

Pyrrol Orange *Cadmium Red Medium*

Each cube is formed with three mostly straight-from-the-tube colors. The color on the top of the cube is the lightest value, the color on the left side is a middle value, and the color on the right side of the cube is the darkest value. Even though the colors on each plane of the cubes are pure hues, a sense of three-dimensional form develops because the colors are visually organized by value.

Play with 2-D and 3-D in a painting

materials

Paper ✳ 22" x 14" (56cm x 36cm) black cover paper, weight 250 gm/m²

Brushes ✳ no. 2, 4 and 8 rounds ✳ no. 4 and 8 flats

Acrylic Paints ✳ Anthraquinoid Red ✳ Black ✳ Cadmium Yellow Medium ✳ Hansa Yellow Light ✳ Pearlescent Shimmer ✳ Permanent Green ✳ Phthalo Blue (Green Shade) ✳ Phthalo Green (Blue Shade) ✳ Pyrrol Orange ✳ Quinacridone Gold ✳ Ultramarine Blue ✳ White

Hard Pastels ✳ black ✳ blue ✳ gold ✳ green ✳ orange ✳ red ✳ sienna ✳ violet ✳ white

Other ✳ spray fixative

I love to play with shape and form. Because I use a lot of saturated color and strong shapes, my work tends to be more flat. In some pieces, I enjoy juxtaposing flat space and pattern with deep space and form. In this painting, *Twilight Bird Song*, you'll see how I work through that idea.

 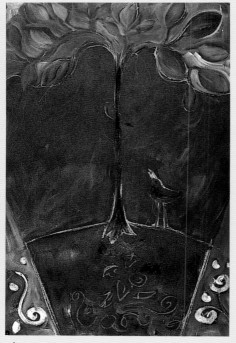

1| Make a Drawing

Begin drawing with a gold pastel. This design came easily to me, so there weren't a lot of exploratory strokes.

2| Start With Dark Colors

Use your paint first, working from dark to light. Keep in mind that the colors you choose will be an underpainting that will show through on the final piece. My background is underpainted in Anthraquinoid Red, the grass and leaves are Phthalo Green, and the rest is Ultramarine Blue.

Black paper gives you a head start when you are painting forms; partially smear a light color on dark paper and you suddenly have a light, middle and dark value in one stroke. Notice how this gives the leaves form.

Drawing white swirls in the sky sets up the sense of motion the final brushstrokes will take. The floral pattern on the bottom of the grassy hill contrasts with the form of the hill. The similar white floral pattern flattens the space of the blue border.

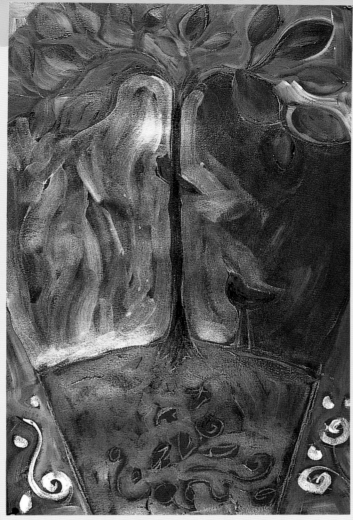

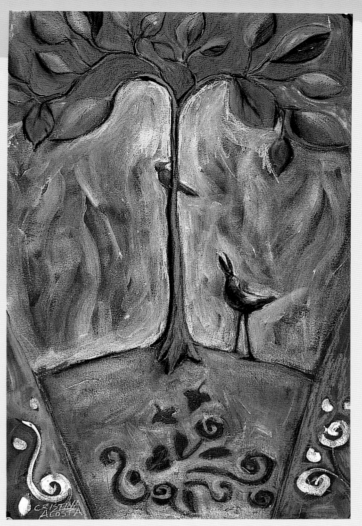

3| Add Lighter Colors

After the dark colors have dried, bring in lighter colors to put on top of the underpainting. Go over the red parts of the background with Quinacridone Gold mixed with Pearlescent Shimmer. Thin layers of Quinacridone Gold were liberally used all over the painting, especially to cover the rest of the initial pastel drawing. Make a variety of greens by mixing Permanent Green and Phthalo Green with Pyrrol Orange, Cadmium Yellow Medium and more Quinacridone Gold. Use the darker greens on the horizon side of the hill and the lighter greens in front, around the pattern. Randomly vary the placement of the different values of green on the leaves.

4| Finish

Use pastels to define the drawing of your piece. To emphasize form, slightly smear some of the black line, then go over the area with a lighter color.

The gold middle area of the painting is where the shapes become forms. Carefully draw the tree trunk with a sienna pastel on top of a brown mixed from Anthraquinoid Red, Permanent Green and some Quinacridone Gold. Draw the birds with blue, purple, red and black pastels on top of the painted dark value (Ultramarine Blue mixed with a bit of Anthraquinoid Red and Phthalo Blue).

Paint the shapes of the black floral pattern on the grassy hill and refine them with pastel. For the sky, mix Quinacridone Gold with Pearlescent Shimmer and apply thick swirls of paint in a vertical direction, taking care not to touch a brushstroke more than once. Finish with spray fixative.

Notice how the flat patterns on the bottom anchor the three-dimensional forms in the middle of the image. The crown of the tree is a pattern of leaf forms and shapes.

Tip

Use colors with strongly contrasting dark values and light values to emphasize three-dimensional form.

Color and Value Balance

C olor is so exciting. It's evocative; it sets a mood; it plays a tune. It can tell you where you are and what time of the day it is. Color is the best part of painting. In chapter three you learned about the mechanics of color, which is essential before you can really learn the language of color. This chapter is about using color as a language. As you become more proficient, you will be able to become specific with the feeling you create in your painting. Shapes and forms take on new meaning when formed with an array of colors.

You have used variation and repetition to explore aspects of shape, line and movement in paintings. Now you'll apply those same concepts to the design elements of color. The elements of color you will work with are: (1) saturated colors and tints, (2) warm and cool colors, and (3) limited color schemes using monochromatic and analogous colors.

Study these concepts consciously, then relax and forget about them. When you need to remember, your subconscious will bring it up. If you try to consciously remember everything at once, you'll end up paralyzed and stop painting.

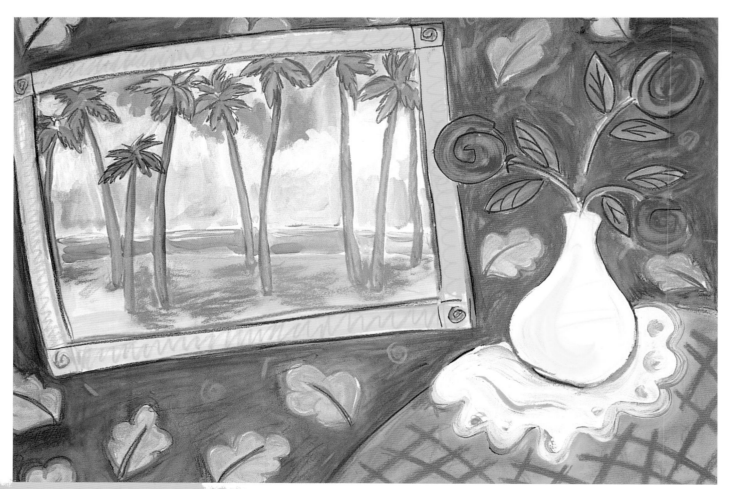

Thinking of Belize • acrylic and pastel on paper • 22" x 30" (56cm x 76cm) • photo by Gary Alvis

Cool blues, violets and greens surround the warm pink-and-gold arch of the dancing couple. To emphasize movement, I repeated warm accents in the cool areas of color and cool accents in the warm area. White is repeated in varying sizes of shapes all over the painting. This leads your eye from the couple to the border and back to the couple. The strong hues repeat with little variation of value. The variation occurs in the different shapes the hues take on in each part of the image.

Two to Tango · acrylic and pastel on paper · 22" x 15" (56cm x 38cm)

Saturated colors *and* tints

Saturated colors are pure and strong. They are bright or deep colors that tend to be assertive and straight-forward. *Tints* are colors that have been subdued. Tints are light and airy colors that tend to be comparatively restrained and sometimes even reserved.

Mix a color with white and see the difference this makes. The change can range from a slight softening of a color to creating a very soft, light pastel. Tinted colors also tend to be a bit cooler. Because of this, saturated colors appear to come forward in space and the tints appear to recede. Sometimes, to counteract the cooling of a tint, you may mix in a small amount of a warmer color or use Buff Titanium instead of pure white to tint the color. Experiment with the effects you create.

The wild energy of color and movement in this image finds a moment of serenity as it surrounds an angel. This painting is about 20 percent tints and 80 percent saturated color. The saturated hues frame the central figure of the angel. The serene mood of her face is emphasized by the use of comparatively restrained tints. The strong shape of her wings is painted with tints of bluish white and yellowish white. The deep space of sky is implied by the blue tint under the angel's wings.

Angel Comfort · acrylic and pastel with silver and gold leaf on paper · 22" x 30" (56cm x 76cm) · photo by Gary Alvis

This example shows how, in the most simplistic way, saturated colors appear closer to you than their tints. Notice how the water and sky are divided into four distinct areas of space. The color saturation of the boats and the water they float on is the same. The distant third boat lies on the horizon line against the lightest blue that your mind reads as sky.

Despite the strong surface pattern of this simple example, the illusion of distance is present. The illusion of distance is also created by varying the sizes of the shapes of the boats.

Warm *and* cool colors

In chapter three you learned how to sense the warmth and coolness of colors. In the simplest terms, reds, yellows and oranges are warm colors; blues, greens and violets are cool colors. In the paintings on these pages, you see that either a cool or a warm color scheme dominates. Within those color schemes, notice the variation of the dominant color family.

The actual warmth or coolness of a color is always relative. The temperature you perceive a particular color to be is completely dependent upon its surrounding colors. Adding a little Cadmium Orange to Permanent Green makes the resulting ivy green a warmer color, especially when compared to a much bluer green like Phthalo Green. A bright pink made with Quinacridone Pink and a little white looks much cooler than orange and much warmer than blue.

Play with the ratio of color balance by creating a color family. Create your dominant color family with a grouping of colors that are generally of similar temperature, such as purple, blue and green. Accent it with the opposite color family of red, orange and yellow, using the accent family in a ratio of 10 to 30 percent of the painting.

Look at the following examples, and then try these variations using an image you already have.

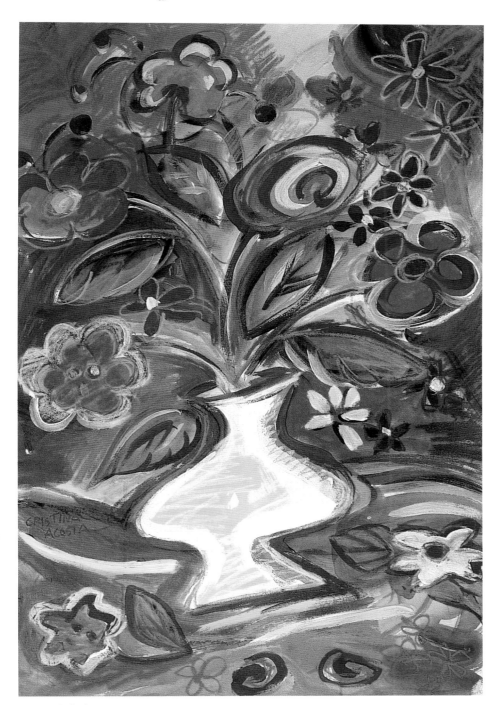

Keeping It Cool

Flowers from my summer garden were the inspiration for this painting and the one on the next page. The feeling is light, casual and loose, like a summer bouquet. The two versions show two ways of conveying a feeling using the same subject but with different color families. This painting has mostly cool colors.

Within the cool colors you can see relative changes. The turquoise of the flowers appears warmer than the surrounding deep blue outlines. That same turquoise, when used near yellow on the vase and the bottom of the paper, appears cooler. The initial drawing was a light blue pastel, and the painted lines are Ultramarine Blue. Overall, the painting is about 80 percent cool colors and 20 percent warm colors.

Flower Party Vase • acrylic and pastel on paper • 22" x 15" (56cm x 38cm)

Warming It Up

This version is composed primarily of warm reds, oranges and yellows. The yellows and reds are fully saturated and hot, like a summer sun. You can see that adding white areas and white to some of the colors helped to unify the image by keeping the saturated colors from being too loud. The yellow becomes relatively cool when surrounded by red and warm when near blue and green.

The initial drawing was a light yellow pastel, and the painted lines are Anthraquinoid Red. The painting is about 80 percent warm colors and 20 percent cool.

Flower Party Vase II · acrylic and pastel on paper · 22" x 15" (56cm x 38cm)

Warming up a painting

materials

Paper ✳ 22" x 30" (56cm x 76cm), minimum 90-lb. (190gsm) weight

Brushes ✳ no. 6 bright ✳ no. 12, 8 and 4 rounds ✳ no. 4 flat

Acrylic Paints ✳ Anthraquinoid Red ✳ Cadmium Orange (or use Pyrrol with Cadmium Yellow Medium) ✳ Cadmium Red Medium ✳ Cadmium Yellow Medium ✳ Carbazole Violet ✳ Hansa Yellow Light ✳ Permanent Green ✳ Phthalo Blue (Green Shade) ✳ Phthalo Green (Blue Shade) ✳ Pyrrol Orange ✳ Quinacridone Pink ✳ Titanium White ✳ Ultramarine Blue ✳ White

Hard Pastels ✳ black ✳ gold ✳ light violet ✳ medium blue ✳ orange ✳ purple ✳ red ✳ white ✳ yellow ✳ yellow-green

Other ✳ spray fixative

In this demonstration, *Laundry on the Line*, you'll learn how to completely reverse the color balance ratio of your painting. Experiment—it's a fun and interesting way to get more than one painting out of the same idea! I began with a painting I'd already done that was mostly cool in its color balance. The challenge is to hold onto the initial impulse that created the original painting, then repaint it with an entirely opposite color family.

Original Image

This ceramic tile mural, *Laundry List*, was created with a cool-to-warm ratio of 90 percent to 10 percent. Because the image is summery, I varied the blues from a deep dark blue to a comparatively warmer turquoise. That way, within the cool coloration, there would be a warmer psychological feeling to the image. I painted the entire image in blues because the client, a manufacturer, was going to use the image for a floor mat. If the painting had too many light areas, the mat would look dirty! Within that constraint, I wanted the final image to have the feel of a summer day. I scattered warm yellows, oranges, pinks and violets across the image to accentuate the sense of visual movement.

1| Make a Drawing

Begin drawing with a yellow pastel. The paper size is different from the original mural, so alter the proportions of the drawing to fit. Change some of the image a bit so you won't get bored making an exact copy. When you have what you want, switch to a gold pastel and redraw the image so you can see it better.

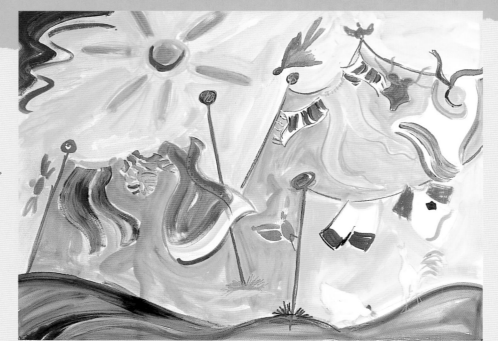

2| Paint First Washes

Lay in the paints in watery washes of pure color straight from the tube. The original had three colors of "sky" (blue) making up the background, so I decided to use three colors of "sun"—two yellows and Pyrrol Orange. Some of the clothing was kept the same color, while others were changed if I felt the change would be good for the entire image. The left corner really needed a cool accent, so the blue squiggle area appeared.

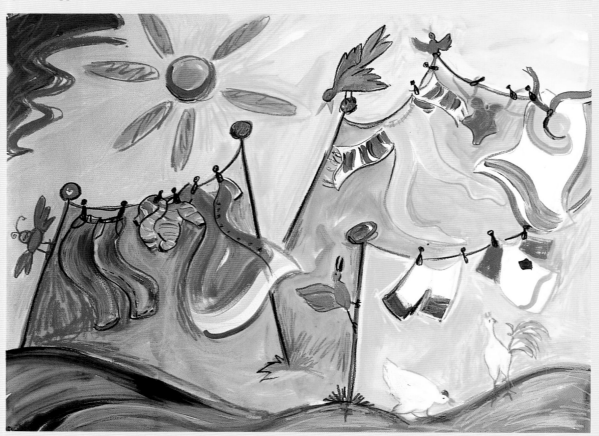

3| Begin Using Pastels

Begin working on the rest of the image with pastels. I ended up adjusting the grass color with some Cadmium Yellow Medium. The grass seemed too cool and was throwing my color balance more to the cool side than I wanted it to be. At this point, I no longer looked at the original painting, *Laundry List*. This new painting needed to be itself. Spray the pastel work with fixative every so often, especially when using black.

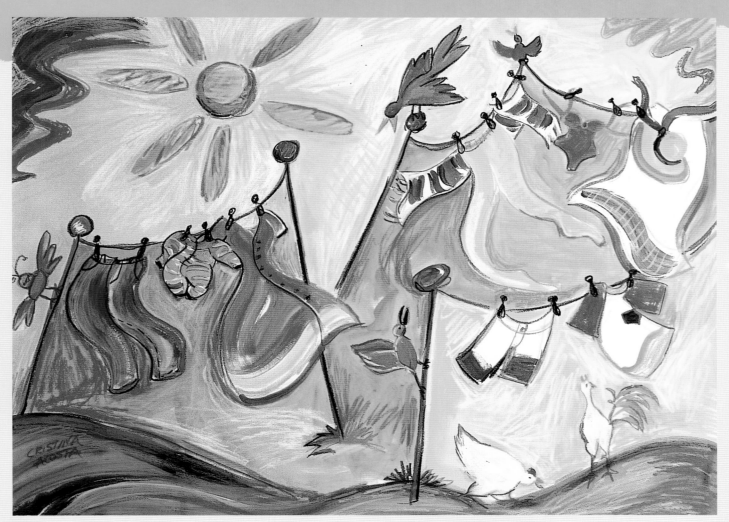

4| Finish

Fine-tune with more pastel work. The dominant warm color scheme (90 percent) enlivens the image, making it even more cheery than the original. I overlaid quite a bit of the yellow areas with a scribbling of white pastel; it seemed to increase the effect of a warm, windy summer day. White softened the yellow so it wouldn't be too loud. The Ultramarine Blue squiggle on the upper left corner was brought down with a scribble of white and counter-balanced with an embellishment of more blue in the green grass areas on the lower left corner of the image.

Tip

You can mix color physically with your brush or palette knife or visually with your eyes. The nineteenth-century French painter Georges Seurat developed the science of visually mixing colors by placing tiny dots of pure pigments next to each other. As the viewer increases his distance from the painting, his eye begins to mix the colored dots into a new color. Drawing with different-colored pastels over an existing color can have a similar effect. Study the work of Seurat, and your insight into color use will increase.

Cooling down a painting

In the last demonstration, you saw what a remarkable difference reversing the dominant color scheme from cool to warm makes to an image. Now try going in the opposite direction. The important thing to keep in mind when reversing color families in an image is to keep the percentage of variation and repetition of the value balance similar.

Carefully study the following demonstration, and then try the same thing with one of your paintings.

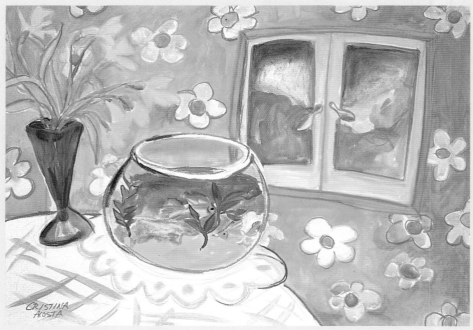

Original Painting

This painting, *Goldfish and Daffodils,* is based on a memory of my grandmother's breakfast nook. She often kept fresh flowers on the table and would open the windows to let the sea breeze waft through. Though visually literal in some ways, this image is more literal to the feeling the memory of that room evokes rather than an exact replication. This painting is very warmly keyed, with orange being the dominant color.

1| Make a Drawing

Begin with light violet pastel, then redraw in pink when the proportions are where you want them. The original and the new paper are the same size. For fun, I adjusted a few proportions just to see what the difference (if any) would be.

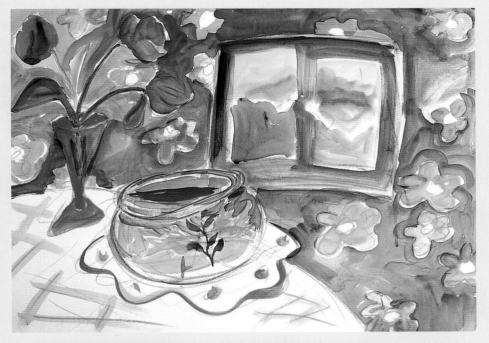

2| Paint First Washes

Lay in color washes, using colors mostly straight from the tube mixed with water. Use a little acrylic flow release to facilitate the flow of the washes. I put the original painting in front of me, then proceeded to reverse the color scheme to one of opposite temperature. The orange background became its complement, blue. Washes of Ultramarine Blue and Phthalo Blue cover the background.

I continued around the painting, creating purple flowers instead of yellow and a red vase instead of a blue vase. Even the sky depicted through the cottage window changed. I wasn't completely committed to the original or to my goal of change. Not everything changed—the goldfish bowl remained very similar. What's important is that the overall warmth of the painting changes to an overall coolness.

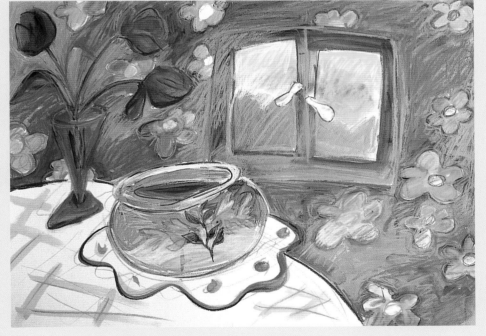

3| Add Pastels

Begin drawing with pastels. I held at least three colors of hard pastel in my left hand and then, as I scribbled over the painted areas, I changed color almost randomly. As soon as the intuition hit to switch to a different color, I switched. At this point I put away the painting *Goldfish and Daffodils*. What had begun as a wonderful inspiration was threatening to control the new painting.

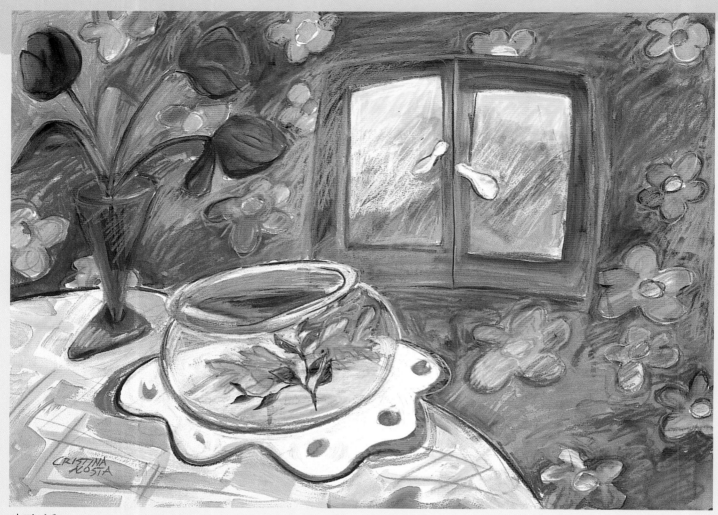

4| Finish

Continue to add pastels and paint where you think it's needed. I used paint mainly in areas where my pastels were already in place and adding more would have reduced the effect of fresh color. Before adding paint over pastel, remember to spray fixative to reduce smearing.

As I worked on the painting, I thought of my grandmother and her artful cooking. The finished piece is livelier than the first painting. The cool blues, greens, purples and pinks are darker in value than the original's dominant oranges. This causes the yellow and red to pop with vibrant life.

A little goes *a* long way: limited color schemes

Limited color schemes are simplistic and often very beautiful. Limiting your color options gives you an opportunity to play with the value range of your color choices. You will learn two methods to limit a color scheme. One method is to choose a triad of analogous colors. The second method is to use monochromatic colors.

Good Neighbors: Analogous Colors

Remember the color mixing exercises you did in chapter three? Analogous colors are those hues that are next to each other on the color wheel. Because no complementary color is present, it is virtually impossible to create a neutral. When you can't create a neutral, you also can't create "mud" (otherwise referred to as brown). Without being able to create brown, a beginner stands a better chance of creating a painting whose colors look clean and fresh.

On the downside, a limited palette is, well, limiting! Without complements, the world of color is a lot less fun. Try painting your own versions of the following examples to get a good feel for working with a limited palette. When you return to painting with a full palette, you'll be bursting with a new enthusiasm for color.

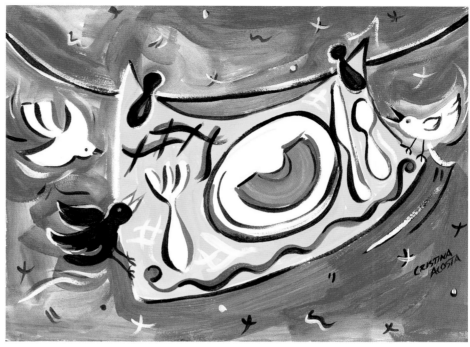

This painting is a cartoon type of drawing colored with paint. The analogous color triad of yellow, green and blue is accentuated with white and black rather than having any black mixed with the colors.

Good Enough to Eat · acrylic on paper · 11" x 15" (28cm x 38cm)

This sketch was made with the analogous colors of Cadmium Yellow Medium, Pyrrol Orange and Cadmium Red Medium. Use an analogous color scheme when you want to simplify an image while still using bright, clean color.

It's All the Same: Monochromatic Colors

A monochromatic color scheme is one of extreme simplicity. At its most basic, it is simply one color with white. The term *monochromatic* is often used to describe a color scheme that is mostly value variations of a single color. Most of the work I do is anything but monochromatic; nonetheless, learning how to create an image within the limits of a monochromatic color scheme is an important skill.

In the last chapter you learned how a shape takes on form. You explored how you can create the illusion of three-dimensionality by creating strong value changes to form a cube. Painters who primarily work with creating the illusion of three-dimensional form often use limited palettes with great success. Like most anything, moderation is essential. If you overuse any particular tool, the result will be a bit tired looking.

Practice painting monochromatically, and you will become very familiar with the value range you can achieve with the colors you use. Begin painting the most basic monochromatic color scheme: one color with white. For your second study, work with neutrals. Finally, paint with only one color mixed with black and white. Look at these examples, and play with the concept in your own painting.

Quinacridone Pink + White

Ultramarine Blue + White

These birds were created with colors straight from the tube, then mixed with white in various amounts. The value range you can achieve depends upon the color you start with. The darker in value the hue is to begin with, the broader the value range you can have.

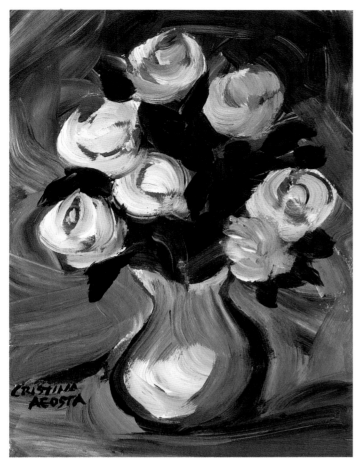

White with
Ultramarine Blue +
Pyrrol Orange

White with
Quinacridone Gold +
Pyrrol Orange +
Carbazole Violet

White with
Anthraquinoid Red +
Permanent Green +
Pyrrol Orange

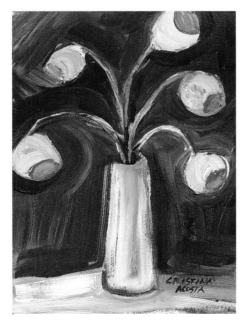

White with Cadmium Red Medium + Permanent
Green

Now mix some neutrals and paint a few potted flowers. These sketches are more flatly painted. Not much attention is paid to the passage of light over their forms. The patterns of the leaves and flowers are emphasized.

Because a neutral is a more complex color than a hue straight from the tube, you will find that you can mix more subtle tints that give you a slightly broader value range to work with. Mix the following neutrals, then add white to lighten the value of your color.

Space

Depth of space in painting is like water—it can be as thin as a sprinkling of rain on a summer picnic, or it can seem as deep as an ocean canyon.

Paintings are made with one or more of the different types of space. An artist may develop a distinctive style that relies on one type of space or a unique way of combining different layers of space. Imagine the depth of space in a painting as being composed of layers.

You have learned to manipulate shapes, line and color to create images. As your understanding of different design elements has increased, you've been inadvertently learning about space. So if some of this chapter seems sort of familiar, it is!

As you discovered earlier, paintings often have several different types of design elements working together to create a strong image. Keep in mind when you look at a painting that the image may be composed of a combination of the different types of space. You will refine your knowledge about space by concentrating on the most basic types of space regularly used in painting: flat space, space created with forms, deep space and ambiguous space.

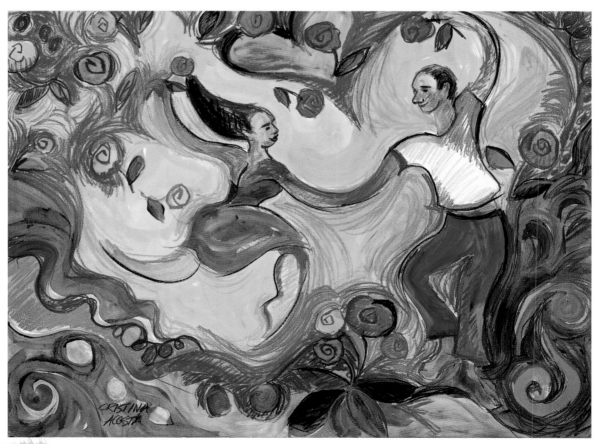

The Lovers • acrylic and pastel on paper • 22" x 30" (56cm x 76cm) • photo by Gary Alvis

Flat space

Think of flat space as a pattern on your paper, a pattern that goes across the two-dimensional surface. An image created to emphasize flat space is always consistent with the surface on which it is painted.

In chapter two, you got your first lesson in patterned space when you made puzzle-piece drawings and paintings. Connecting the image shapes to the sides of the paper and each other created strong patterns. In chapter four, you learned to see an image in layers. Flat space can exist on its own as a pattern, or it can be the most basic design layer of a painting.

Generally, the perception of flatness applies to most patterns, but as with everything in painting, you can find an exception to any rule. Stare at an image long enough and even flat patterns can seem to move in three-dimensional space.

The space of this painting is flat to the point of being a pattern. The entire surface of the image consistently has the same pattern of values and colors. The objects are shapes, not forms. Every part of the image seems to be floating at the same level, as though you flew a helicopter over the sea and looked directly down onto the flat surface of the ocean.

Tropical Sea • acrylic on paper • 17" x 24" (43cm x 61cm) • From *When Woman Became the Sea*, written by Susan Strauss, illustrated by Cristina Acosta. Hillsboro, Oregon: Beyond Words Publishing, 1998.

Try This!

French painter Henri Matisse devoted the last several years of his life to working with flat space and color. His paper cutout works of abstract shapes are visual symphonies of beautifully orchestrated color, line and shape. To increase your understanding of flat space, look up Matisse's images from his book *Jazz,* which was originally published in 1947 (a reprint was published in May 2001 by Prestel USA).

Study Matisse, and then create some shapes with colored paper. Cut them out and glue them to a larger square of paper. Vary the sizes, shapes and colors to create a pleasing composition. These may become finished works of art or ideas for a more complex painting.

Space created *with* forms

When you transform a shape into a form, your mind immediately reads the surrounding area as space rather than shape. The trick is to keep in mind that the surrounding area exists as shape *and* space.

Space created with forms is similar to a wall relief sculpture: You may notice that parts jump out at you or that other parts recede. Find a wall relief sculpture of a landscape. Notice that no matter how "deep" the landscape depicted is supposed to be, it is really only as deep as the material it is created with. In paintings, you can use forms in the compressed way that a wall sculpture may, or you can treat your canvas like a window and create the illusion that your piece exists in a real place with greater depth.

Space created with forms is often found in portraits, still lifes and some landscapes. This is also what I call the second layer, or surface layer, of the piece upon which the basic design is elaborated, as you learned in chapter four.

Forms have their own interior space as well. You have learned to create forms using line, color, value and edges.

In this example, the pumpkins and grass are forms, and the cats and the night sky are flat shapes. The night sky could also be read by your eye as the form of sky, so that it has depth. Based on that assumption, about 20 percent of this painting is flat space, and the remaining 80 percent is form.

None of the forms are fully modeled. The pumpkins are rather flatly painted—only two values of orange are used. The grass is also primarily two values, as is the sky. The lack of value range within each area contributes to the overall feeling of compressed space.

Black Cats and Pumpkins · acrylic on canvas · 8" x 11" (20cm x 28cm)

About ten years ago, before I began painting "happy," I often painted oil sketches on location with my French easel. These young girls modeled for me on a winter morning in a old church recreation hall. The solid forms of the girls and the piano occupy the finite space of a room, defined by the walls. Recording the passage of light over the forms of the girls and the piano gives the forms a "realistic" room space within which to exist.

At the Piano · oil on board · 16" x 15" (41cm x 38cm) · collection of Teresa Acosta · photo by Gary Alvis

Deep space

Deep space turns your paper into a window on another world. The view may seem to go on for miles. Simply, deep space is all about depth: combining layers of space to create the illusion of a foreground, middle ground and background. You will often see deep space depicted in traditional landscape painting.

Even greater depth is created if the background layer of space has atmospheric areas that are foggy and vague. Atmospheric space is a subcategory of deep space. Atmospheric space is the vapor that blurs the far horizon, making the distant mountains or the line of the sea seem to blend almost seamlessly with the sky. It's the tool used to create a sense of endless depth.

Tip

Whenever you work on one part of your painting, keep your peripheral vision engaged so that you can see the effect your concentrated work is having on the other parts of the image. Every few minutes, focus about an inch or two (three to five centimeters) in front of your paper to enhance your peripheral perception.

This painting is a classic representation of the layers of space. The table of flowers and food is in the foreground of the image. The orange tree and French doors are in the middle ground, and the background drops off behind the stone balustrade toward the island. The colors in the foreground are most intense, and the colors become paler as they progress into the background.

Beautiful Day · acrylic and pastel on paper · 22" x 30" (56cm x 76cm) · photo by Gary Alvis

This image was organized with a foreground, middle ground and background. The sizes of the stepping-stones diminish as they recede into the garden. The sunflowers in the foreground garden are proportionally larger than the lemon tree in the middle ground. The space in this painting could go much deeper if I increased the contrast in values between the colors in the foreground and the background, making the foreground more intense.

When I paint, my interest lies primarily in movement, shape and color, so I do not emphasize the use of traditional landscape space division. I created this image by starting with this traditional space division, then "flattening" the space by making the violet of the background mountain similar to that of the foreground flowers, and by making the blue sky of the background the same value as the green grass of the foreground.

Sunflower Garden • acrylic and pastel on paper • 22" x 30" (56cm x 76cm) • photo by Gary Alvis

 Tip

Keep these concepts in mind when you create space with color and value:

• Intense colors tend to come toward you and muted colors tend to recede. (This is more about value than color.)

• Warm colors tend to come toward you and cool colors tend to recede. (This is more about color than value.)

• Overall, dark values are used in the foreground and lighter values are used to create the perception of distance in the background. Within a form, this idea can be reversed.

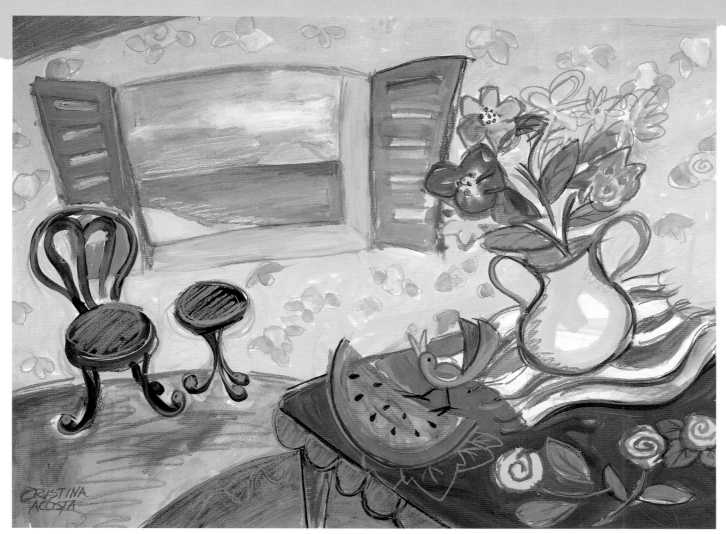

This painting has a compressed foreground and middle ground (the chair and shutters). The compression is contrasted with the third layer of space, which is the background ocean and island. Even that layer has been compressed a bit; I could have used the tools of atmospheric space to create more depth. Instead, I decided to stick with my theme of compressed space and leave the edges of the shapes in that area harder rather than blurred. Downplaying the value range that deep space would have required allows me emphasize color and the rhythm of line.

Southshore Island Song · acrylic and pastel on paper · 22" x 30" (56cm x 76cm) · photo by Gary Alvis

Tip

Soften edges of objects and areas in your painting to create a sense of atmospheric space. Review the chapter four pages about edges. If you want to emphasize atmosphere, look for edges to soften. If you want to emphasize the presence of a shape or form, use hard edges.

I painted a series of these pieces (a little over a dozen) approximately seven years ago, right before my "paint happy" work became my dominant style. The work of nineteenth-century English painter Joseph Turner was an influence for this series.

This painting was constructed using value and an almost monochromatic color scheme. The forms of the trees are described with indefinite sketchy brushstrokes. The edges of the painted areas are often blurred. This contributes to a sense of deep atmospheric space.

The bright, shiny copper overlays bring your eye back to the surface and create some of the few hard edges in the piece. The contrast between the bright copper surface and the dark softness of the landscape creates an ambiguous tension between the atmospheric space and the surface texture.

Twilights Deep · oil, tempera and wax medium with copper metal leaf on board · 23" x 30" (58cm x 76cm) · collection of Bob Dietz · photo by Gary Alvis

This piece relies exclusively on value and fractured, softened edges to create a sense of atmospheric space. The reflective metal leaf, when tarnished and the edges softened, enhances the sense of atmospheric space. The overlays of shiny metal leaf emphasize the surface of the image, moving your eyes forward before they drop back into the depths of the image. The limited color palette and fragmented texture combined with the subject matter lend the image a sense of melancholy.

The Dance · oil, tempera, acids and wax medium with copper metal leaf on board · 25" x 25" (64cm x 64cm) · photo by Gary Alvis

Ambiguous space

Ambiguous space is my favorite type. Essentially, it is space that can change depending on how you look at it. In some paintings, as your eye looks over the image, you'll find that the spaces seem to change and that an area you thought of as deep space now becomes flat space. You notice the surface texture more than the illusion it creates.

In much of my work, I play with juxtaposing flat space and pattern with various layers of form and deep space. The difference between ambiguous space and a bad painting is usually some combination of intention and luck. There is no right or wrong way to juxtapose different types of space. Each artist walks a fine line between beauty and chaos, success and failure.

When you paint, the spaces you see are created both on the surface of your paper and in your mind. What you *think* you see affects you as much as what you actually *do* see. Keep in mind the ambiguity of the illusion you create. Paintings that work well on more than one level of space continually invite the viewer back into them.

In *Two Birds*, the flat shapes of copper leaf flora, painted birds and flowers contrast with the atmospheric space created with soft, edgeless areas of color that seem to melt into each other. This painting is a result of melding my techniques of working with metal with my current style. The richness of color enhances the atmospheric space, and, at the same time, the bright copper restates the two-dimensional surface of the canvas. This contrast creates an ambiguity in the perception of the space of this painting.

Two Birds · oil and copper leaf on canvas · 36" x 24" (91cm x 61cm)

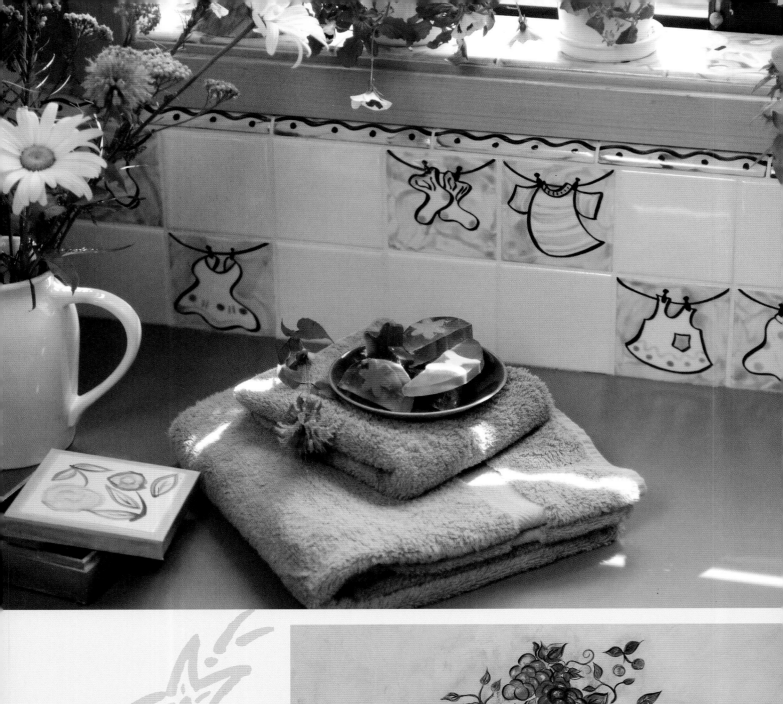

Cristina Acosta

Paint Your Home Happy

Being an artist is a wonderful adventure. The more time you put into your creative self, the more creativity and enjoyment flows from you. Your creativity begins to bubble out in all sorts of ways. In this chapter you will get an introduction to the possibilities when you apply your artistic vision around your home. Creating beauty for your home enriches your life and the lives of those around you.

Trying new mediums—and surfaces—can be very challenging. You may feel like you have to learn again from the absolute beginning. Stay positive; the medium may be different, but you are not at zero with your artistic skills. Keep in mind that the concepts you have worked with in this book translate to any medium.

Colorful ceramics

The magical transformation of loose earth and minerals into a ceramic object is one of the most intriguing aspects of creating with clay. Intense temperatures change the texture and color of glazes and make opening the kiln a surprise, and not always a good one! Working with ceramics has taught me that mistakes are unavoidable and can even gift me with a new and more interesting result than I ever could have imagined.

The world of ceramics is huge. The best way to figure out what you need to learn is to first decide what you want to make. Keeping the end in mind, research the different methods and choose the one that seems easiest. If you learn that one and are interested in learning more, you may proceed to more complicated methods.

If you're interested in tile painting but aren't about to tear up your house, investigate the offerings in a nearby craft store. There are paints available that can be applied to an existing tile backsplash or to glass tableware.

A good introduction to working with kiln-fired ceramics is to go to a commercial studio. The studio supplies the paints, glazes and items you need to get started. You can start with a simple bowl, plate or piece of tile, and the studio fires it for you.

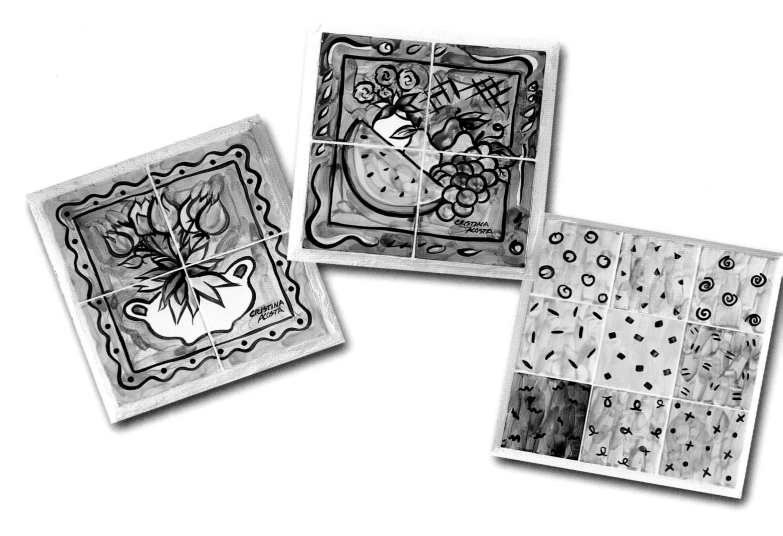

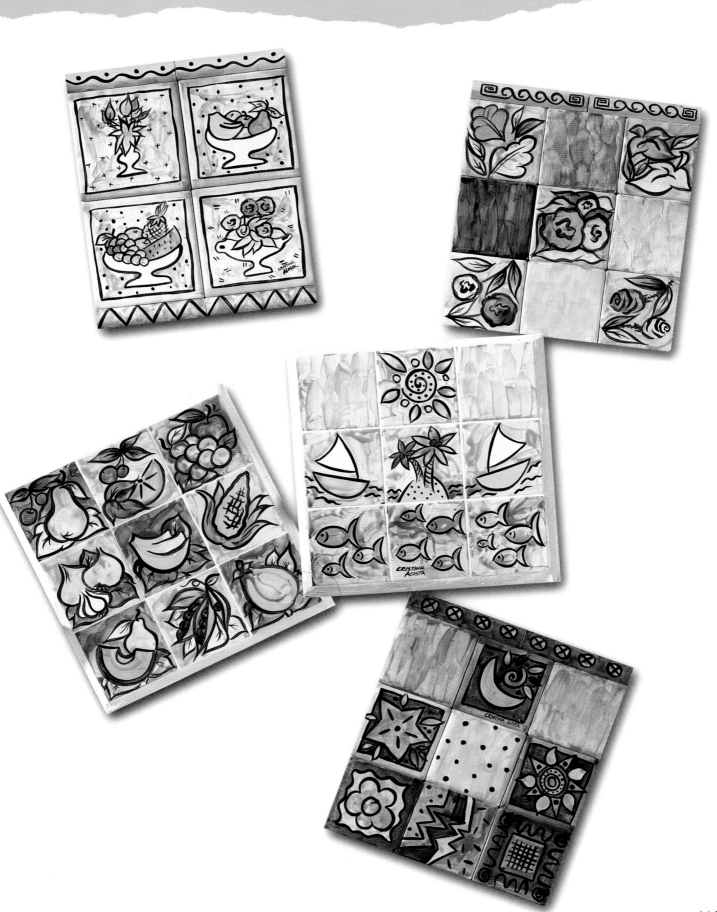

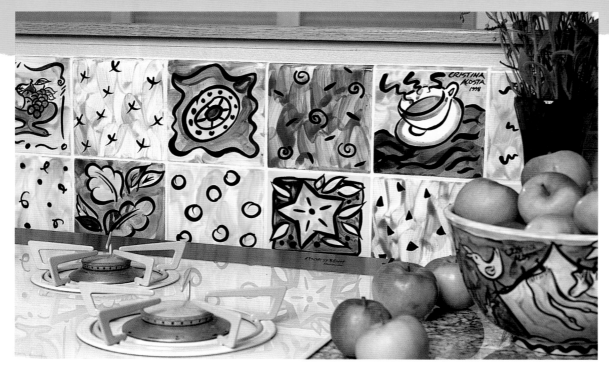

My kitchen is so fun and colorful that I love looking at it every day. It inspires me to cook creatively and is a natural gathering place for my friends and family.

If you don't want to install tiles for a back-splash, look for other ways to use decorative tiles. Use them as trivets, or glue some tiles with tile adhesive onto a wooden board and you can make a fun wall hanging, table runner or mirror surround.

(Photo by Gary Alvis)

Tip

Creating accessories with tile is much easier than you may think. A full-service tile store that caters to homeowners and trades-people usually rents ceramic saws for any cuts you need, or they may do the cuts for you for a minimal fee. Carefully explain your project, and they can give you advice about the tools and materials you need for success.

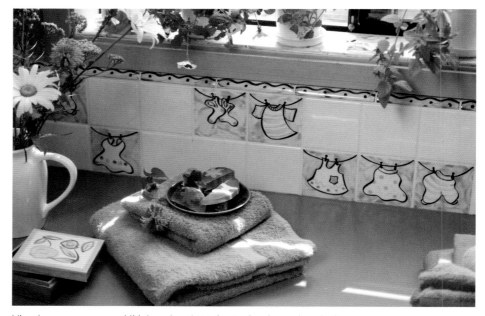

When I was a very young child, I used to sit on the sand under our laundry line and watch the ocean breeze swirl the drying clothing into a rhythm of snapping and crackling ever-changing shapes. This experience inspired me to design this set of laundry room tiles. The squiggle/dot pattern on the quarter-round trim recalls the ocean and grass. Let your own experiences inspire your creations.

(Photo by Kevin Kubota)

Lush colors and vibrant design define these fun pieces of tableware. I started with molded bisqueware (plain, unglazed pottery) purchased from a ceramics supplier and painted it with one-stroke underglazes. After firing that design, I coated the piece with a clear satin glaze and fired it again. The finished tableware is permanently painted and safe for food.

(Photo by Gary Alvis)

Make your designs true to your life. I painted my dog's favorite poses on her dog biscuit canister. Just like the tableware, I started with molded bisqueware and painted and glazed it, making sure to carefully coat both the inside and outside of the canister and lid. The final glaze was a clear gloss.

(Photo by Loren Irving)

Tip

An easy way to get started in painting ceramics is to try a paint-your-own-pottery store. Find a contemporary ceramic studio in your local phone book under "Ceramics." Take a few friends with you, and relax and have fun.

The studio will have a variety of bisqueware pieces for you to choose from, and the staff can give you a quick lesson in technique with the underglazes (colored "paints") they supply. Studios often include the final clear glaze coat in the price. The fee is usually based on the item you choose to paint and sometimes includes an hourly charge as well. Getting an idea of what to paint will come easily, as the studio will have samples and photos for your inspiration.

The studio will do all the firing for you, and your pottery is usually ready for pickup within a day or two.

Marvelous mosaics

You'll find that the painting skills you developed while exploring the sizes and types of shapes will translate directly to the art of mosaic tile.

Start with small projects that are flat. A little planning helps with the installation. If you are careful and like a controlled outcome, plan your piece thoroughly on a large, flat surface and arrange it before setting any of the tiles.

That's not the only way to work: If you are an intuitive risk taker, just start with the first tile piece that is in your hand. Whichever method works for you, make sure you pay careful attention to the entire work area as you proceed. Chipping off cemented tile can be done if you make a mistake or change your mind, but it's not fun.

Vary the shapes and sizes of the pieces you use to create your mosaic. Play with color ratios, using the concept of variation and repetition as a guideline.

Create mosaic lamps for your home. These thirty-six-inch-high (91cm) lamps create a wonderful focal point in a room. I used previously painted tiles and broke them with either a hammer or tile clippers into a variety of shapes. Colored grout set off the designs, and I painted the shades with acrylic paints to coordinate with the tiles.

The lamp base is ceramic bisqueware. You are not limited in materials; any roughened wood or metal will work for a lamp, too. Be wary of plastic, as the grout may not adhere permanently to the surface. If you are unsure, test a small area of the surface before you commit to the entire project.

(Photo by Gary Alvis)

To make this stepping-stone, I began by sealing the concrete base and gluing onto it a variety of shapes and sizes of tiles with special adhesive. I used a warm-colored grout to tip the overall color balance of the tiles to the warm side. The cool blue colors make up about 30 percent of the piece. Because I use this stepping-stone outside, I bought a water-based tile sealant from a tile supply store and generously applied several coats to the entire stone.

Fun furniture *and* fabrics

You can completely transform an anonymous piece of furniture or textile into something wonderful that is truly yours by painting it. You can paint on furniture using artist acrylics or oils. Acrylics may not adhere to an existing finish, so you may need to have the piece stripped before you begin. Oil-based paints are usually strong enough on their own (especially enamels). If you have any doubts about durability, seal the piece with a wood sealer appropriate for your paint medium. Any good paint store can help you with products.

Fabric painting is a bit more technical. While you can use your acrylic paints on fabrics, they often make fabrics stiff. You can use them successfully if they are sufficiently watered down, but deep saturated hues will not be possible. Look for acrylic paints with a full range of color made especially for fabrics. They are available at most craft stores.

On the Front...
This 6' x 6' (2m x 2m) tripanel wood folding screen is painted on both sides with oils and metal leaf. This image, called *The Garden of Earthly Delights*, began as three female figures and ended up looking like this. So much for preparatory sketches!

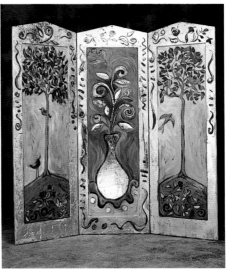

...and the Back
On this side of the screen, the images are influenced by medieval European religious painting. Overall, the image is not religious, but a mythic patina seems to pervade the piece. That which influences you will eventually integrate into your style if you work long enough. When that happens, the influence may remain obvious, but the piece will be obviously yours.

(Photos by Gary Alvis)

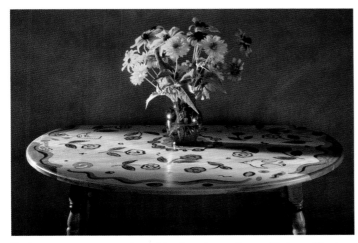

The best way to get a new piece of furniture is to paint an old piece of furniture! The first rule for me is to be sure I am not painting a piece of furniture that is so valuable (as an antique or collectible) that to paint it destroys history. With that in mind, I found this simple maple kitchen table, stripped it, and, using acrylic paints, painted on it a simple pattern of flowers and birds. I sealed the table with an acrylic wood sealer.

(Photo by Kevin Kubota)

Paint fun accent pillows to decorate your room. I painted this design using acrylic fabric paint on plain cotton bedding.

(Photo by Loren Irving)

Walls *with* style

Painting your walls is the easiest way to surround yourself with beauty. Start with an entire room, or paint just an accent wall or area.

Begin by choosing your colors. Think about color and your experiences with particular colors.

Cultures around the world assign meaning to colors. Along with cultural norms, you have personal experiences with color that are very powerful and often are subconscious. Study the Chinese art of feng shui, and you'll learn that certain colors enhance or depress the energy of a home. When you paint the walls of your home, you do not just color a wall; you change the energy of the room and how you feel in that room.

Consider favorite colors that you enjoy wearing or the colors of the foods you love. The color of your favorite coffee or tea drink might be a great color to begin with!

If you have a favorite place to visit, think of the colors present in that landscape. Visualize your favorite time of day or season of the year. Maybe it's the color of the earth surrounding your childhood home or the color of a favorite flower. All of these places and things reinforce your feelings of happiness and can influence your palette. I knew I had the right color for my living room ceiling when I saw that not only did it work with the other colors I used in that room, but it was the perfect match to a favorite food of mine—French vanilla ice cream!

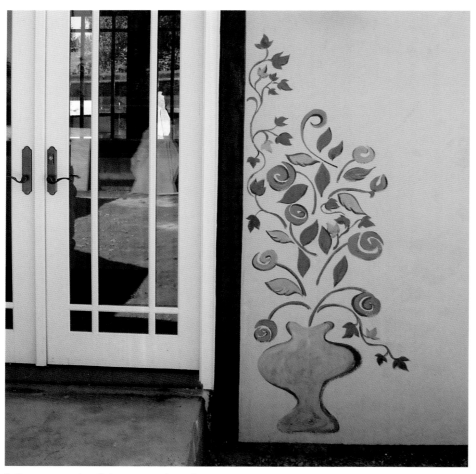

Enliven your outdoor living space with small murals and motifs. These flowers that can be enjoyed year round were painted with acrylics mixed with some terra-cotta latex house paint. Remember, latex and acrylic are compatible when mixed. This can save you money and help you integrate your mural into the color scheme of the surrounding area. The painting is lightfast and durable. If you need extra weather protection, spray or brush on clear polyurethane.

(Photo by Brian Orlov)

Flowers and cherries placed around a light switch spruce up plain areas of a wall where it's not easy to hang a picture. I painted these to coordinate with the fruit and vegetable mural on page 100. The methods and materials are the same. Before I painted the images, I first ragged a taupe-colored latex paint in a very diluted (with acrylic medium) wash over the cream-colored plaster. I painted with my acrylics, then used a small kitchen scrubbing pad sponge to gently eliminate some of the paint. This had the effect of visually "pushing back" the designs so that they wouldn't be too loud of a presence in the room.

(Photo by Brian Orlov)

Wall mural

Living with a mural is as close as you can get to living "in" a painting. Murals bring color and life to any wall, whether they are complex and detailed or only a simple embellishment. Don't let the thought of painting a mural intimidate you. Keep in mind—it's only paint! If you are nervous about failing, keep a quart of the wall color close at hand for quick and easy erasing.

For this kitchen mural, I used acrylic paints and latex wall paint in the base wall color, which I mixed into some of my acrylics when creating colors. I used no. 12 and 8 round brushes, no. 12 and 8 flat brushes and a 2-inch (50mm) housepainting brush of high quality.

Finished Mural

1| Create a Drawing

I began by thinking about the home. It is a contemporary home with colorful accents and a happy feel. With that in mind, I didn't do much of a preparatory drawing, just a quick sketch on a scrap of paper to give me the general direction of my image. On the wall, I began with a piece of chalk and sketched the placement and general image. Once I began actually working on the wall, the image seemed to mature.

2| Make an Underpainting

I chose a base color for the image by coordinating it with the surrounding woodwork in the room. Doing this helps the image relate to its surroundings and works to integrate the mural with the room. I didn't slavishly follow the lines I initially put down in chalk. I let the brush flow naturally to create each curve and squiggle.

3| Add Colors
Next I added color without worrying too much about the underpainting showing through. I made each brushstroke count, taking care not to overwork any area.

4| Finish
The image seemed to be finished until the homeowner and I pondered it. Somehow it just seemed too isolated, so I added a border under the pot and some little bits of the fruit and a flower motif on adjacent walls.

The house has strong color accents and is filled with sunlight and natural wood accents. The plain blue wall was a natural focal point when considered with the surrounding architecture. This image works well with the existing décor and has enlivened the blue wall.

(Photos by Kevin Kubota)

Index

"When I create, angels whisper into my ears and dance from my fingertips."

Acrylic Landscape Painting Techniques

Packed with inspirational artwork, four complete painting demonstrations and 21 mini-demos, this guide provides step-by-step instructions for rendering a variety of landscape elements, including trees, flowers, roads and reflections. You'll also find guidelines for mastering general acrylic painting techniques such as masking, spattering, underpainting, washes and more.

ISBN 1-58180-063-0, hardcover, 128 pages, #31915-K

Discover the Joy of Acrylic Painting

Learn how to properly execute basic acrylic painting techniques—stippling, blending, glazing, masking or wet-in-wet—and get great results every time. Jacqueline Penney provides five complete, step-by-step demonstrations that show you how, including a flower-covered mountainside, sand dunes and sailboats, a forest of spruce trees and ferns, a tranquil island hideaway and a mist-shrouded ocean.

ISBN 1-58180-042-8, hardcover, 128 pages, #31896-K

Painting Nature's Little Creatures

Render the smallest of animals into living works of art! Step-by-step mini-demos show you how to replicate the most intimate animal features. Stephen Koury provides background information and detailed descriptions for a variety of creatures, including butterflies, bees, spiders, dragonflies, beetles, amphibians, hummingbirds and small mammals.

ISBN 1-58180-162-9, hardcover, 144 pages, #31911-K

How to Keep a Sketchbook Journal

Claudia Nice introduces you to the joys of keeping a sketchbook journal, along with advice and encouragement for keeping your own. Exactly what goes in your journal is up to you. Sketch quickly or paint with care. Write about what you see. The choice is yours—and the memories you'll preserve will last a lifetime.

ISBN 1-58180-044-4, hardcover, 128 pages, #31912-K

Discover how much fun painting can be!